FÜR IMMER WAR GESTERN

MICHAEL SAILSTORFER

FÜR IMMER WAR GESTERN

MICHAEL SAILSTORFER

Verlag für moderne Kunst Nürnberg

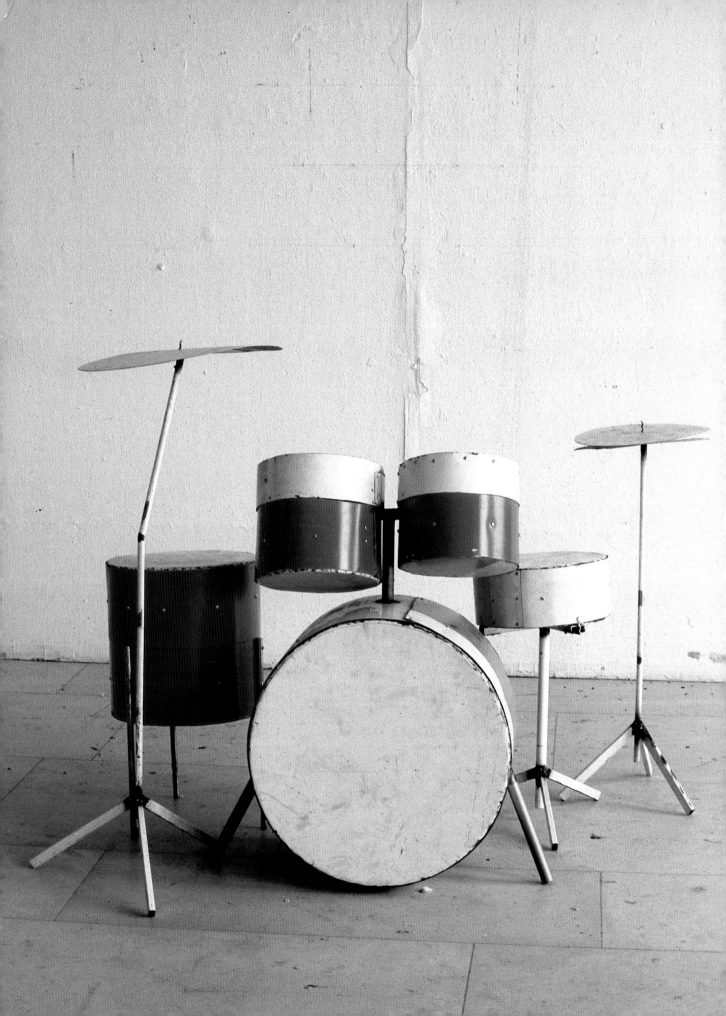

Vorwort

In den letzten Jahren hat man den Eindruck gewinnen können, dass gerade die „klassisch" anmutenden Gattungen der Malerei und Skulptur unter den jüngeren Künstlerinnen und Künstlern eine enorme Attraktivität gewonnen haben. Das kunsthistorische Fundament, das diese Gattungen gegenüber anderen wie der Installation, dem Video, der Performance besitzen, erweist sich offensichtlich als Herausforderung, jenseits des Imperativs des radikal Neuen, das Wissen um das Bestehende produktiv zu nutzen.

Michael Sailstorfer ist Bildhauer. Das meint in diesem Fall einen präzisen Umgang mit der Kategorie des Skulpturalen, den alle seine Werke aufweisen, eine Bezugnahme zu bestimmten Materialien, es meint den Prozess der Materialtransformation und der objekthaften Bedeutungsverschiebung. Sailstorfer arbeitet entlang der Konnotationen verschiedener Oberflächen und Objekte, die er ihrem ursprünglichen Zusammenhang entfremdet und in neue Kontexte fügt. Entgegen ihrer eigentlichen Funktion eingesetzte oder einer neuen Bestimmung zugeführte Gegenstände bilden die Basis seiner Werke, die profane Dingwelten auf poetische wie subversive Weise transzendieren.

Wenn diese Werke nicht im Kontext einer Ausstellung gezeigt werden, platzieren sie sich meist im Außenraum. Es handelt sich jedoch nicht um den so oft skulptural besetzten öffentlichen urbanen Raum. Es handelt sich vielmehr um Landschaftsräume, in denen die klassische Dichotomie von Natur und Kultur ein weiteres, überraschendes Mal zur Aufführung kommen kann. Sailstorfers skulpturale Objekte wirken in diesen Landschaftsräumen einerseits wie Fremdkörper, sind andererseits aber in der Lage, aus der scheinbaren Deplatziertheit heraus einprägsame Metaphern zu formulieren. Die in die Einsamkeit der niederbayerischen Landschaft gesetzten Wohnmobile, die sich in eine einsame Hütte verwandelt haben (*Heimatlied,* 2001), sprechen zum Beispiel vom Ankommen und Bleiben, von der still gestellten Mobilität und der Landschaft, die sich nur im Vergleich mit der Stadt als solche noch wahrnehmen lässt.

Die *Sternschnuppe* (2002) wiederum, die im Garten der Ursula Blickle Stiftung im badischen Kraichtal gezeigt wurde, besteht aus einer auf einem alten Mercedes befestigten

Abschussrampe für eine Straßenlaterne. Mit Hilfe eines Katapultes auf dem Wagendach kann die Laterne in den Himmel befördert werden. Sie würde dann theoretisch auch ein Stück weit fliegen, am Ende aber unwiederbringlich am Boden zerschellen. Mit solchen zweckrationalen Spekulationen kommt man jedoch nicht weit. Vielleicht will die funktionstüchtige Konstruktion aus Auto und Laterne gar nicht funktionieren, sondern davon erzählen, was alles passieren könnte, wenn wir die Dinge in Bausteine einer Wirklichkeit verwandelten, die unseren Sehnsüchten Ausdruck verleiht.

Diese Sehnsüchte spiegeln sich vor allem in der besonderen Form von Zeitlichkeit, die den das Fundament von Sailstorfers skulpturalen Anordnungen und Anverwandlungen bildenden Dingen sowie allen uns umgebenden Objektwelten direkt oder indirekt eingeschrieben ist – die Zeitlichkeit des langsamen Zerfalls, die des Herausfallens aus der Wertschöpfungskette, die des Erinnerns an frühere Begegnungen mit den Dingen. Wenn Michael Sailstorfer Autos, Flugzeuge oder Straßenlaternen zu neuen Konstellationen fügt, ist diesen alltäglichen Gegenständen ihre ganz eigene Zeitlichkeit über Design und Gebrauchsspuren eingeprägt. Und auch das, was aus ihnen entsteht, eröffnet nicht nur ein eigenes Reich der Zeichen, sondern auch eines der Zeit: des einfachen Da-Seins, des langsamen Verschwindens, der explosiven Präsenz. Die imaginären Potenziale, die in den Dingen stecken, liegen dann plötzlich frei, ihre subversive Energie jenseits funktionaler Zwänge ist entfesselt. Man sieht Sailstorfers Objekten den Spaß an, den sie daran haben, unser Denken aus den geordneten Bahnen des Bekannten und Vertrauten zu drängen. Man sieht ihnen aber auch die leichte Melancholie an, die entsteht, wenn die Subversion des Sinns sichtbar wird.

Die Antwort auf diesen melancholischen Grundton liegt vielleicht in der Ästhetik des Moments und der ständigen Veränderung. In der ebenfalls in der Ursula Blickle Stiftung installierten Außenarbeit *Elektrosex* (2005) beispielsweise neigen sich zwei Straßenlaternen sanft entgegen, so dass sie sich beinahe berühren. In regelmäßigen Abständen entlädt sich zwischen den beiden Lampen eine Ladung Strom in Form elektrischer Blitze,

die Emotion in sichtbare elektromagnetische Impulse verwandeln. Die in dem Garten ohnehin surreal wirkenden Straßenlaternen sprechen dann von sichtbarer Energie, von zärtlichen Stromstößen, von der unsichtbaren Innenwelt vertraut scheinender Lichtquellen. Sie sind, was sie sind, und doch etwas ganz anderes.

Das gilt auch für die anderen Werke Michael Sailstorfers, die eigentlich nur in der Begegnung mit ihrer Präsenz vor Ort adäquat zu erfassen sind. Die vorliegende Publikation gibt, so hoffe ich, dennoch einen anschaulichen Einblick in das Werk eines Bildhauers, der dieser so klassischen Gattung eine neue Dimension verliehen hat, gerade weil er die Dinge, wie sie sind, in ihrer Materialität und Form ernst nimmt und freisetzt, was in ihnen vielleicht schon immer latent vorhanden war.

Ich bedanke mich sehr bei den Autoren Simone Subal, Massimiliano Gioni, Max Hollein und Johan Frederik Hartle für ihre Beiträge in diesem Katalog. Michael Sailstorfer danke ich sehr herzlich für die gute Zusammenarbeit bei der Entwicklung der Ausstellung in der Ursula Blickle Stiftung. Weiterhin gilt mein herzlicher Dank Katja Schroeder für ihre vermittelnde und organisatorische Unterstützung des Projektes sowie Ludwig Seibert und Mike Stiegler für ihren tatkräftigen Einsatz bei der Realisation des Aufbaus. Mein ganz besonderer Dank jedoch gilt Ursula Blickle selbst, ohne die diese Ausstellung und dieser Katalog nicht möglich gewesen wären und die mit viel persönlichem Engagement zu ihrem Gelingen beigetragen hat.

Nicolaus Schafhausen

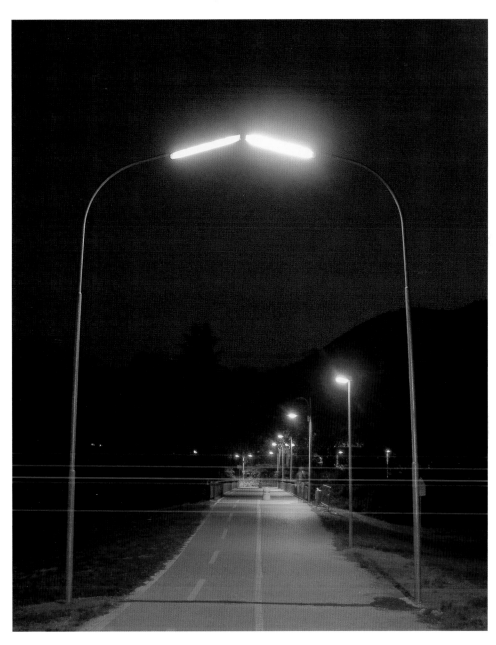

ELEKTROSEX
2005

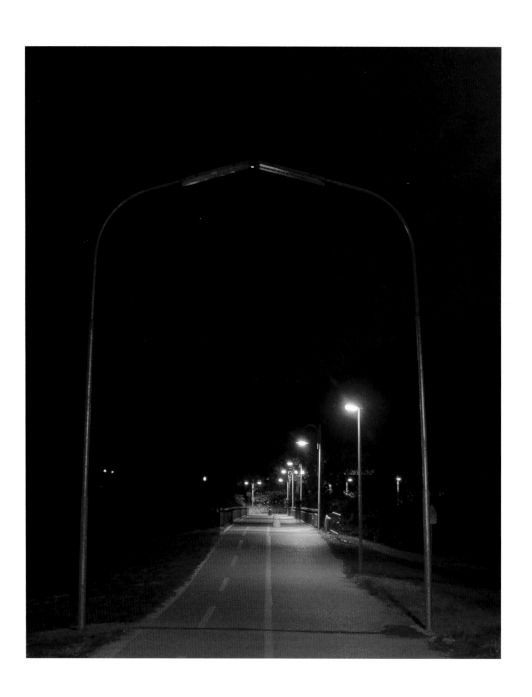

Foreword

In recent years one might have gained the impression that precisely the ostensibly "classical" genres of painting and sculpture have become immensely appealing to younger artists. Evidently, the strong foundations in art history that these genres enjoy as compared with others such as installations, videos, or performance is a real challenge to bring a knowledge of what is productively to bear beyond the imperative to create something radically new.

Michael Sailstorfer is a sculptor. In this case, this means that he has a precise approach to the category of the sculptural, something all his works possess, a reference to particular materials; it likewise refers to the process of transforming materials and shifting meanings in objects. Sailstorfer works along the fine line of the connotations of various surfaces and objects, taking them out of their original content and placing them in new settings. His oeuvre rests on objects utilized in contrast to their actual function or given a new destiny – his works transcend the profane world of things in a poetic and subversive manner.

If these works are not shown in the context of an exhibition then they are usually to be found outdoors. However, this is not a matter of public urban spaces such as are so often sculpturally upgraded. Rather, they are landscape spaces in which the classical dichotomy nature and culture is staged in a new and surprising manner. In these countryside settings, Sailstorfer's sculptural objects function as alien bodies and yet are able to formulate striking metaphors for all their ostensible dislocation. The trailers placed in the solitude of the Lower Bavarian countryside that have turned into a lonely hut (*Heimatlied,* Homeland song, 2001) speak, for example, of arriving and staying, of frozen mobility and the countryside that can only be perceived as such by contrasting it with the city.

The *Sternschnuppe* (Shooting star, 2002), which is on display in the gardens of the Ursula Blickle Stiftung in Kraichtal in Baden, consists of a launchpad for a street lantern fastened to an old Mercedes. The lantern can be sent skyward by means of a catapult on the car roof. It would, theoretically, fly a certain distance before inevitably falling

to earth. Such purposive-rational speculation does not get us very far. Perhaps the functioning construction consisting of car and lantern does not want to function in the first place, but to tell the tale of all the things that could happen if we turned things into the building blocks of a reality that lent expression to our desires.

These desires are reflected above all in the special form of time that is directly or indirectly inscribed in the things that form the foundation of Sailstorfer's sculptural arrangements and transformative appropriations, and in the worlds of objects that surround us. It is the time of slow decay, of self-extraction from the value-added chain, of memories of former encounters with the things. When Michael Sailstorfer places autos, airplanes or street lanterns in new constellations these everyday objects bear their very own time, inscribed through design and the traces of their use. And what arises through them likewise not only opens up a special realm of signs, but also one of time: of simple being there, of gradual disappearance, of explosive presence. The imaginary potential innate in the objects is then suddenly exposed, their subversive energy unleashed beyond all functional compulsions. Sailstorfer's objects readily show the fun they have in forcing our thought off the familiar straight and narrow. Yet they also attest to a sense of slight melancholy that arises when the subversion of meaning becomes apparent.

The response to this underlying melancholic tone is perhaps to be found in the aesthetics of the moment and constant change. Likewise installed outdoors at the Ursula Blickle Stiftung, *Elektrosex* (Electrosex, 2005), for example, has two street lanterns lean tenderly toward each other so that they almost touch. In regular intervals, an electric charge is triggered between them in the form of flashes of electricity, transforming emotion into visible electromagnetic impulses. The street lanterns seem surreal in the garden anyway and yet thus attest to a visible energy, to tender electric shocks, to the invisible interior world of seemingly familiar sources of light. They are what they are and yet they are something quite different.

The same is true of Michael Sailstorfer's other works that can actually only adequately be grasped by encountering their presence on location. The present publication, or so I would hope, provides a vivid impression of the oeuvre of a sculptor who has created a new dimension to this so classical genre, precisely be takes the things seriously as they are, in their material existence and form, and releases what was perhaps always latent in them.

I would very much like to thank the authors Simone Subal, Massimilano Gioni, Max Hollein and Johan Frederik Hartle for their essays for this catalogue. I am deeply grateful to Michael Sailstorfer for his staunch collaboration in devising the exhibition for the Ursula Blickle Stiftung. My cordial thanks also goes to Katja Schroeder for her support organizing and communicating the project, and to Ludwig Seibert and Mike Stiegler for their valiant efforts in assembling the exhibition. However, my very special thanks goes to Ursula Blickle herself, without whom this exhibition and this catalogue would simply not have been possible and who contributed with such strong zest and personal commitment to it being a success.

Nicolaus Schafhausen

Michael Sailstorfer

Umformungen, Kontextverschiebungen, räumliche Inbesitznahmen – sehr rasch erkennt man in Sailstorfers Arbeiten sein Interesse an den Dingen des Alltags, den Materialien der unmittelbaren Umgebung, seine hemdsärmelige Faszination für die spezifische Identität und Geschichte dieser Objekte und die Schicksale, die diese evozieren können, kurzum die inhärenten Assoziationen, die sie auslösen und die sich Sailstorfer nun zu Nutze machen kann. Dabei nimmt er sich diese Objekte regelrecht vor, sie werden zerlegt, auseinander genommen, deformiert, adaptiert, neu zusammengesetzt, deplatziert, umgedeutet und umgewidmet. Eine solche Deformation von Sinn und Zweck des Objekts unter Ausnutzung und Beibehaltung seiner formalen Qualitäten hat nicht eine Zerstörung zur Folge, vielmehr ist das Ziel eine Neuanordnung und Bedeutungsumschichtung. Dabei ist sowohl der Raum, den sie einnehmen, als auch der Raum, der sie umgibt von essentieller Bedeutung. Selbst kleinere Objekte von Sailstorfer sind in diesem Sinne Installationen, inhaltlich integral mit der Identität des Ortes der Aufstellung verbunden.

Das ist die erste, formal rezipierbare Ebene. Doch das macht noch nicht die Stärke und Originalität von Sailstorfers Arbeiten aus. Denn in all seinen Arbeiten schwebt auch ein ungemein poetischer Geist. Ein Gefühl für Sentiment, das nicht konstruiert oder kalkuliert ist, sondern das integraler Bestandteil der Werke selbst ist und vom Künstler mit absoluter Sicherheit erspürt wird. Selbst sein Lehrjahr am Goldsmiths College in London, einer der Kaderschmieden für theorielastiges künstlerisches Arbeiten, hat Sailstorfer von diesem Weg nicht abgebracht, im Gegenteil, vielleicht sogar weiterhin bestärkt. Nahezu erleichtert erkennen wir, dass sich dieser Künstler nicht in den Wirren einer hochkomplexen, selbstreferenziellen, formalästhetischen Objektanordnung verliert, sondern sich als praktischer Träumer in der beseelten Welt der Dinge erweist. Es sind das Aufblitzen der Sehnsucht bei der Zielsetzung, die melancholische Komik der Umsetzung und die bewusste Tragik im Moment des Erreichens der Ziele, die die Arbeiten von Sailstorfer so außerordentlich machen.

Sternschnuppe (2002), die für mich bisher großartigste Arbeit von Michael Sailstorfer, hat eine ungemein poetische Kraft in der Idee, eine nahezu komisch-gefährlich technoide Anmutung in der Ausführung und eine bis ins Herz gehende tragische Note im

Resultat: Der Künstler entpuppt sich zuerst als romantischer Träumer, der nicht mehr auf den lieben Gott angewiesen sein möchte, wenn ihn der Wunsch überkommt, eine Sternschnuppe am Himmel sehen zu wollen. Es ist kein beherrschender, sondern ein nahezu kindlicher Wunsch, einmal selbst ein solches emotionsgeladenes Naturphänomen produzieren zu können. Dazu passt – ob wahr oder nicht – das Geständnis des Künstlers, dass dies eine Arbeit für seine neue Freundin gewesen sei, für die er einen hellen Stern in den Himmel schießen wollte. Jugendlich träumerischer geht es kaum noch. Was sich die Freundin erwartete, wissen wir nicht, aber die Realität ist dann auch oft brachialer als das erste Bild der Vorstellung: der aus diesem Traum resultierende sailstorfersche Apparatus aus einem Mercedes W123 mit Katapultfunktion und eingespannter Straßenleuchte wird zum waffenähnlichen Sternschnuppenabschussapparat. Es ist die simple Umsetzung einer simplen Idee mit simplen Mitteln. Die Sternschnuppe von Sailstorfer, das Surrogat für die schwärmerisch rezipierte Wirklichkeit kommt nicht an das angestrebte Wunder des Naturphänomens heran – die Straßenlaternensternschnuppe fliegt höchstens 15 Meter weit und verglüht nicht im Äther, sondern zerschellt auf dem feuchten Rasen der bayerischen Provinz. Der Akt allerdings hat seine eigene Schönheit. Die Realität ist oft weniger ästhetisch oder romantisch als der Traum. Aber der Wille zählt. In diesem Sinne sind Sailstorfers Objekte und Installationen Ding gewordene Geschichten, fiktive, oft surreale Erzählungen einer individuellen Gefühlswelt.

Selbstporträt mit selbst gestricktem *Nasenwärmer* (2004), das ist der humorvolle, simple Dinge bastelnde nette Künstler, der die handgemachte rote Nase entwickelt und mit dieser praktischen Objekt- und Produktionsform dann doch eine tragische Note und eine Träne im Knopfloch trägt. Diese Mischung aus Komik und Tragik ist auch im Werk *3 Ster mit Ausblick* (2002) inhärent, wo sich ein Holzhaus durch einen Ofen selbst verheizt. Auch sein Polizeibus, der zum *Schlagzeug* (2003) wurde, macht einen relativ traurigen Eindruck – das hat der Polizeibus so sicher nicht gewollt. Schon von Claes Oldenburg und seinen *Soft Drum Sets* wissen wir, wie es um die Stimmung solcher Objekte beschieden ist, wenn man erst einmal ihre Vertrauen erweckende Originalkonsistenz verändert hat. Sailstorfer bezieht bewusst auch Strategien der Kunst vergangener Generatio-

nen ein, nutzt diese, demaskiert aber auch die Tragik ihrer Ernsthaftigkeit. So etwa bei *Waldputz* (2000), der radikalen Eroberung von künstlerischem Raum in wildester Natur durch die Etablierung eines von Hand akribisch gereinigten Waldstücks. Eine künstlerische Aktionsstrategie, die der eines Richard Long oder Michael Heizer nicht nachsteht und doch in der Absurdität der Aufgabe, in der Akribie des Vorgangs und in der Vergänglichkeit des Resultats ein sehnsüchtiges, utopisches und auch tragisches Vorgehen darstellt. Dabei gilt Sailstorfers Interesse dem Endstadium und nicht dem Prozess, der dazu führt. Dies wohl auch wegen der großen narrativen Kraft, die seine Objekte an sich schon haben. Das finale Objekt des künstlerischen Willens beinhaltet eine sehr eigene Geschichte, insofern wäre die Darstellung des prozessualen Vorgangs, um diesen Zustand zu erreichen, nur destruktiv für diesen hochqualitativen Erzählzustand.

Sailstorfers methodische Stärke ist dabei die simple, praktische Herangehensweise. Ein Modellbastler für eine andere Sicht der Welt und eine Neuanordnung der einfachen Dinge. Dieser Geschichtenerzähler geht mit Akkubohrer und Stichsäge zur Sache und hat die Situation fest im Griff – Sie wollen sehen, wie aus einem Segelflugzeug ein Baumhaus wird? Kein Problem, das haben wir gleich – und so werden zwei Sportflugzeuge rasch zum Standardprodukt des jugendlichen Eskapismus umfunktioniert. Seine Installationen basieren auf simplen, nachvollziehbaren Grundstrukturen und sind keine technischen Experimentalanordnungen. Oft geht es dabei auch um das menschliche Streben als Selbstbeschäftigung und Artikulation, um die Notwendigkeit, Spuren zu hinterlassen bzw. diese auch wiederum zu zerstören.

Es gibt kaum eindrucksvollere, melancholischere und träumerischere Arbeiten über ebensolche Seinszustände wie auch über das künstlerische Streben, welches sich in gerade diesen Gefühlslagen artikuliert, wie *Bethlehem* (2004), einer selbst entwickelten, fahrbaren Heils- und Freudenbotschaft, oder *Elektrosex* (2005), der Gegenüberstellung von sich über Entladungen vereinenden, ansonsten ewiglich unbeweglich auf Distanz platzierten Straßenlaternen. Konfrontiert mit diesen sinnlichen, rational nachvollziehbaren, in der Umsetzung ungemein praktischen aber gleichzeitig absurden Arbeiten erkennt man die Poesie der Sehnsucht, die Euphorie innerhalb des Prozesses des Erreichens und die

Melancholie bei Erfüllung der Aufgabe. Heimat, Reise, Ankunft, Beziehung – Sailstorfer, dieser surreale Geschichtenerzähler rund um grundlegende Themen unseres Daseins als Individuum ist vor allem ein Wiederentdecker des Sentiments in der Kunst und im Objekt unserer Zeit.

Max Hollein

Michael Sailstorfer

Transformations, contextual adjustments, spatial appropriation - in Sailstorfer's work one is quick to recognize his interest in everyday objects, materials that surround us, his hands-on fascination with the specific identity and history of these objects and the fate they may evoke – in short the inherent associations they trigger, and which he can now make use of. He really has a good go at these objects, striping them down, taking them apart, deforming, adapting and putting them together anew, displacing reinterpreting and rededicating them. Such a deformation of the meaning and purpose of the object, while at the same time using and retaining its formal qualities does not result in destruction; the aim, rather, is a fresh configuration and a change in meaning. Here, both the space these objects occupy and the space that surrounds them are of essential importance. In this sense even Sailstorfer's smaller objects are installations, integrally bound in context with the identity of the place they are exhibited.

This is the first formally accessible level. But this does not account for the strength and originality of Sailstorfer's works. In all his oeuvres there lingers also an immensely poetic spirit. A feeling for sentiment which is not construed or calculated but which is an integral part of the work and absolutely certain to have been experienced by the artist. Even a year spent studying at Goldsmiths College in London, one of the training grounds for theory-laden artistic work, did not detract Sailstorfer from this path, quite the contrary, it perhaps even strengthened it. We recognize, with something akin to relief, that the artist does not get lost in a whirr of highly complex, self-referential, formally aesthetic configuration of objects, but rather proves to be a practical dreamer in the animated world of objects. What makes Sailstorfer's works so extraordinary are the flashes of longing in their objective, the melancholic humor in the way they are produced and the conscious tragedy in the moment the objective is achieved.

Sternschnuppe (Shooting star, 2002), for me the most important of Sailstorfer's works to date, has an extremely poetic power in its concept, an almost comically dangerous technical feeling about its execution and a heartfelt tragic note in the result: The artist reveals himself initially as a romantic dreamer, who no longer wishes to be reliant on God when he is overcome by the desire to see a shooting star in the sky. It is not an

all-dominating wish, but an almost childlike wish to be able to produce such an emotionally-charged natural phenomenon by himself for once. Whether it is true or not, this goes along with the artist's avowal that it was a work for his new girlfriend, for whom he wanted to shoot a bright star into the sky. And there could hardly be a better example of youthful dreaming than that. We have no idea what the girlfriend was actually expecting, but reality is often more brutal than what one first imagines: The Sailstorfer apparatus resulting from the dream, made from a Mercedes W123 with catapult function and built-in street light, becomes a weapon-like apparatus for launching shooting stars. It is the simple execution of a simple idea with simple means. Sailstorfer's shooting star, the surrogate for the enthusiastically received real thing, comes nowhere near the miracle of the natural phenomenon desired - the streetlight shooting star flies a maximum of 15 meters and does not burn out in the ether, but explodes on the damp ground of provincial Bavaria. But the act has its own beauty. Reality is often less aesthetic and romantic than a dream. But it is the will that counts. In this sense Sailstorfer's objects and installations are stories that have become tangible – fictive, often surreal stories about individual emotions.

Self portrait with hand-knitted *Nasenwärmer* (Nose warmer, 2004), the nice artist who makes humorous, simple things, comes up with a handmade red nose only with this practical object and form of production to wear a tragic note and a teardrop in his buttonhole. This mixture of tragedy and comedy is also inherent in his work *3 Ster mit Ausblick* (3 Steres with a view, 2002), in which a wooden house heats itself by means of a stove. His police van which became *Schlagzeug* (Drumkit, 2003) also makes a relatively sad impression – something that was surely not the police van's original destiny. We already know from Claes Oldenburg and his Soft Drum Sets what the mood of such objects can be once you have changed their trusted original consistency. Sailstorfer also consciously refers to art strategies from past generations, makes use of them while also unmasking the tragedy of their earnestness. As, for example, in the case of *Waldputz* (Forest cleaning, 2000), the radical conquest of artistic space in the wilds of nature by creating a piece of forest meticulously cleaned by hand. An artistic strategy that is eas-

ily on a par with those of Richard Long or Michael Heizer and yet which, in the absurdity of the task, the meticulous way it is carried out and the transitory nature of the result represents a longing, utopian and also tragic approach. Whereby Sailstorfer's interest focuses on the final state, and not the process that leads to it. This is presumably also because of the great narrative power inherent in his objects. The final object of artistic will includes a highly personal unique history and as such depicting the process necessary to reach this state would only be destructive for this high quality narrative state.

The strength inherent in Sailstorfer's methodology is his simple practical approach. Building models to gain a different view of the world and a new configuration of simple things. This particular storyteller gets to work with a power drill and a jig saw and has everything well under control. You want to see how to make a tree house out of a glider? No problem, coming right up – and in a flash two glider planes are quickly turned into the standard product of juvenile escapism. His installations are based on simple, comprehensible basic structures and are not experimental technical arrangements. They are often also to do with a human aspiration for self-occupation and articulation and the necessity of leaving behind traces, or destroying them, as the case may be.

There can scarcely a be more impressive, melancholic and dreamy work than *Bethlehem* (2004) which is about precisely these states of existence as well as the artistic striving that articulates itself in precisely these moods, a self-developed, drivable message of sensation and pleasure, or *Elektrosex* (Electrosex, 2005), in which two lanterns are placed opposite each other, united by discharging electric current, but otherwise placed at a distance from one another, eternally unmovable. Confronted with works such as these, which are sensual, comprehensible in rational terms, extremely practical in terms of their construction, yet at the same time absurd, one recognizes the poetry of yearning, of the euphoria involved in the process of achieving a goal and the melancholy of fulfilling a task. Home, travel, arrival, relationship – Sailstorfer, a surreal storyteller who addresses fundamental themes to do with our existence as individuals, is above all a rediscovery of sentiment in art and the objects of our time.

Max Hollein

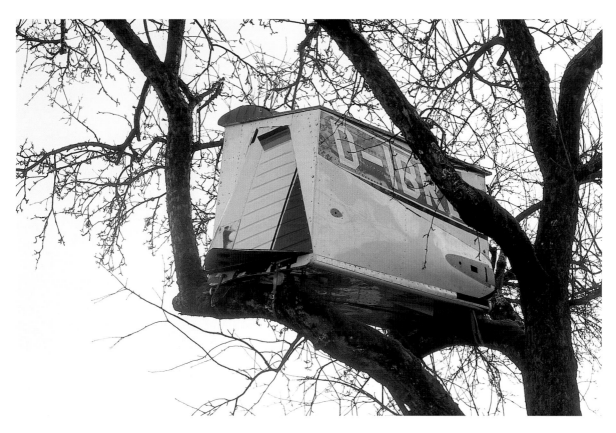

D-IBRB
2002

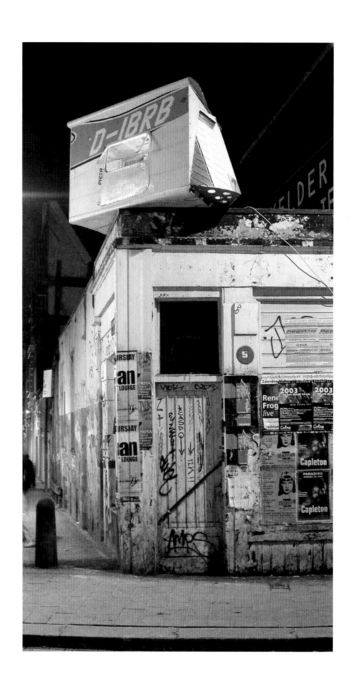

Michael Sailstorfers alchemistische Experimente

„Mir gefällt die Idee, dass man etwas
Neues kreiert, indem man etwas wegnimmt"
Michael Sailstorfer

In Michael Sailstorfers künstlerischer Karriere lassen sich einige wiederkehrende Themen erkennen. So spielt er immer wieder mit Implikationen des Reisens und der Mobilität und stellt diese der Vorstellung gegenüber, ein Zuhause, einen bestimmten Bezugspunkt zu haben. Sailstorfer analysiert diese nomadischen Tendenzen – durch Flugzeuge, Autos und Caravans dargestellt –, indem er sie in stabile häusliche Unterkünfte verwandelt.

Für *Heimatlied* (2001) zum Beispiel demontiert Sailstorfer vier Wohnwagen und baut diese zu einem einzigen, vier Meter langen, Haus zusammen.[1] Dieses mit Elektrizität und Wasser ausgestattete, komplett funktionsfähige Haus liegt inmitten einer hügeligen Landschaft, lediglich von Feldern und ein paar verstreuten Häusern umgeben. Das Äußere erinnert an eine minutiös gefertigte Patchwork-Decke, bei der jedes Segment immer noch etwas über seine vormalige Verwendung verrät. Sailstorfer raubt den Wohnwagen jede Möglichkeit der Mobilität. Dennoch kann der Betrachter vor seinem geistigen Auge die einzelnen Elemente zusammensetzen und so die vier unterschiedlichen Wohnmobile rekonstruieren. Die Teile sind nicht von ihrer ursprünglichen Funktion befreit: die Tür bleibt eine Tür, das Fenster ein Fenster. Sailstorfer versteht jede Komponente als williges Modul. Trotz der etwas ramponierten Materialien behandelt er seine Bausteine mit äußerster Präzision und verschmelzt diese mit beeindruckender Kunstfertigkeit zu einem scheinbar organischen Konstrukt.

Das Interieur vermittelt jedoch ein irritierendes und surreales Gefühl: nichts scheint wirklich passend. Während die neu integrierten Einheiten ohne ihrer schützenden Umgebung deplatziert wirken, verstärkt das unvermeidbare Konglomerat aus Stilen, Mustern und Oberflächenmaterialien diese seltsame Anmutung. Die Fenster zum Beispiel sind niemals in einer Linie ausgerichtet, noch haben sie die gleiche Form, was zur Verwirrung der sinnlichen Wahrnehmung führt. Oft sind diese Abweichungen nur geringfügig. Das Erkennen dieser räumlichen Unbeständigkeiten erfolgt deshalb oftmals verspä-

tet. Entscheidend ist auch, dass Sailstorfer das Innere des Hauses nicht mit Gegenständen verstellt, sondern eine systematische Ordnung bevorzugt – entleert von etwaigen Lebensspuren wie verstreuten Spielsachen, Büchern oder Geschirr. *Heimatlied* erscheint wie die Kulisse eines in Kürze beginnenden unheimlichen Schauspiels.

Diese Wirkung findet in der speziellen Platzierung des Hauses ihren Widerhall. Sailstorfer ist nicht an einer Darstellung des Idyllischen oder Sublimen der Natur interessiert, sondern porträtiert eine typisch deutsche Landschaft; die Parzellen von Ackerland verteilen sich stetig entlang der sanften Hügeln. Seltsamerweise gelingt es uns nicht, eine Person auszumachen, obwohl die Felder, Straßen und angelegten Wege, die Präsenz von Menschen nahelegen. Die Gegenüberstellung dieser banalen Landschaft mit Sailstorfers unpassender Hauskonstruktion verstärkt den merkwürdigen Charakter dieser Szenerie und dessen Verfremdungseffekt.[2] Tatsächlich geht Sailstorfer davon aus, dass seine Installationen ein gewisses Unbehagen erzeugen: „Manchmal werden sie [die Arbeiten] in die Landschaft versetzt, wo sie den Einheimischen wie ein irritierendes Bild erscheinen."[3]

Sailstorfers Anliegen den Betrachter zu verwirren, ist mit Vito Acconcis architektonischen Arbeiten der frühen achtziger Jahre vergleichbar, in denen er die räumliche und psychologische Beziehung zwischen Architektur und Körper untersucht.[4] Acconci kommentierte sein Konzept des Hauses in dem Text *Home-Bodies: An Introduction to my Work 1984–85* folgendermaßen: „Wenn das Haus gemütlich wirkt, wenn man sich hineinkuscheln möchte, dann verliert man sich in der Vergangenheit und Stabilität; wenn das Haus dich jedoch in Unruhe versetzt, wenn du zweimal hinschauen musst, dann trittst du aus der Gegenwart heraus und hast Zeit, über die Zukunft und Veränderungen nachzudenken."[5] Sailstorfers beunruhigendes *Heimatlied* lässt einen auf ähnliche Weise aus der Gegenwart heraustreten wie es bei Acconcis *Bad Dream House* (1983) der Fall ist. Acconci stellt die Struktur des Hauses im wahrsten Sinne des Wortes auf den Kopf, indem er drei Hauskonstruktionen zu einer einzigen, vielschichtigen Behausung vereinigt. Zwei aneinander gelehnte, gekippte Backsteinhäuser bilden das Fundament für ein drittes, vermeintlich stabiles Glashaus. Acconci verbindet diese drei Häuser, um einen irritierenden Innenraum zu schaffen.

Spielerisch bringt Acconci die Orientierung des Betrachters durcheinander und nimmt ihm damit die Möglichkeit, die Konstruktion als eine Einheit wahrzunehmen. So sind die Decken der Backsteinhäuser, die nun als Böden fungieren, himmelblau gestrichen, während die ursprünglichen Bodenflächen als aus dem Lot geratene Decken grasgrün sind. Acconcis *Bad Dream House* kann als Antithese des amerikanischen Traumes gesehen werden: es verwirft jeglichen Sinn von Sicherheit oder Solidität des privaten Zuhauses. Indem das Raumgefühl des Betrachters gestört wird, hinterfragt *Bad Dream House* die Gültigkeit dieser für das Selbstverständnis der amerikanischen Identität so wesentlichen Begriffe.

Sailstorfer überträgt einige von Acconcis Ideen in einen deutschen Kontext. Während Acconcis Installationen in ein städtisches Szenario eingebettet sind, transponiert Sailstorfers *Heimatlied* Fragen der Behausung in eine bayerische Landschaft. Hier tritt, anstelle der spontanen Reaktion und Interaktion der Öffentlichkeit auf Acconcis Arbeit, eine örtliche Verlagerung, die einen subversiven Unterton erzeugt. Diese surreale Empfindung wird durch die greifbare Authentizität der zerlegten Wohnmobile kontrastiert (und zugleich verstärkt). Im Gegensatz zu Acconcis Arbeiten vor Ort, verweisen die Wohnwagen auf ein früheres Leben und erzählen vier verschiedene Geschichten über ihre gebändigte Mobilität.

Beide Künstler betrachten die Struktur des Hauses als ein geeignetes Mittel, ihre künstlerischen Ideen auszudrücken. „Einige von uns," so behauptet Acconci, „[…] haben das Haus als Prototyp gewählt, um an das allgemeine Wissen und den gewöhnlichen Gebrauch der Leute anzuknüpfen, da das Haus als ein Ort angenommen werden kann, wo man nicht mit Widerständen wie ‚Kunst' konfrontiert wird, der Ort kann als ein Mittel betrachtet werden, als eine Gelegenheit zur sozialen Interaktion und kulturellen Neubetrachtung."[6] Sailstorfer greift diese Vorstellung auf, indem er seinen Hang, mit vertrauten Objekten zu arbeiten, zur Geltung bringt: „Ich möchte, dass meine Arbeit dem Leben nahe ist, oder wenn man so will parallel zu meinem Leben, deshalb habe ich begonnen, mit vertrauten Dingen zu arbeiten, die mich umgeben."[7] Sowohl *Heimatlied* als auch *Bad Dream House* spielen mit der allzu einfachen Möglichkeit des vordergründigen Erkennens, in das sich Momente der Irritation einschleichen.

Wohnen mit Verkehrsanbindung von 2001 vereint diese bereits erwähnten Aspekte und ist eine von Sailstorfers zahlreichen skulpturalen Eingriffe im öffentlichen Raum – diesmal in vier kleinen Orten in Süddeutschland; Anzing, Großkatzbach, Oberkorb und Urtlfting.[8] Sailstorfer hat für dieses Projekt vier Bushaltestellenhäuschen mit ‚Überlebens‘-Möbeln ausgestattet. Die Werkbeschreibung verzeichnet Komponenten wie Bushaltestelle, Tür, Strom, Wasser, Küche, Bett, Tisch, Stuhl und Beleuchtung. Selbst eine Toilette fand ihren rechtmäßigen Platz. Alles funktioniert und steht zur Benutzung bereit. Das Mobiliar ist mit seinen reduzierten geometrischen Linien äußerst minimal und dessen Form korrespondiert sowohl mit der Produktionsmethode als auch mit der Endfunktion. Auch hier spielt Sailstorfer mit der Konnotation des Reisenden, nimmt ihm jedoch die Aura des Verheißungsvollen und hebt hingegen die Realität der Umstände hervor: das endlose Warten auf einen Bus. In diesen kleinen Dörfern stellt der Bus eine wichtige Verbindung zur Welt dar. Infolgedessen bietet Sailstorfer dem Pendler nicht nur Schutz, sondern verwandelt diesen Ort vergeudeter Zeit in etwas Nützliches.

Während Sailstorfer die Funktionalität der Bushäuschen optimiert, hinterfragt er zugleich auf ironische Weise die Idee von Mobilität. Diese Bushaltestellen wurden nicht für einen Ausstellungskontext entworfen, sondern stellen eine lokale Realität dar. Als öffentliche Orte haben diese Warteräume bestimmte Verhaltensmuster konditioniert, welche durch Sailstorfers Intervention in Frage gestellt werden. Was für eine unerwartete Entdeckung: anstatt der standardisierten Wartebänke steht eine komprimierte, jedoch funktionierende ‚Lebenseinheit‘ zur Verfügung, die allerdings mit anderen Pendlern geteilt werden muss. Mit diesem Eingriff erzeugt Sailstorfer ein Gefühl der Verrückung ins Vertraute.

Sailstorfer hat diese kurzlebigen Installationen in einer Serie von acht Schwarz-Weiß-Fotos dokumentiert. Die in der Dämmerung aufgenommenen, nur teilweise beleuchteten Bushäuschen wirken unheimlich und muten weniger wie Orte der Geborgenheit und des Schutzes, sondern wie leer geräumte, vernachlässigte Filmkulissen an. Das unbehandelte und verwitterte Holz bildet einen scharfen Kontrast zu den klinisch weißen Möbeln. Ähnlich dem Interieur in *Heimatlied*, wurden auch hier alle Spuren einer tatsächlichen

Nutzung getilgt. Oder vielleicht gab es diese nie? *Wohnen mit Verkehrsanbindung* ist Sailstorfers unzugänglichste und düsterste Arbeit, in der das ursprünglich Spielerische durch seinen speziellen Einsatz der Schwarz-Weiß-Fotos annulliert wird.

Tatsächlich finden sich in Sailstorfers Arbeit immer wieder zwei oder auch mehrere gegenläufige Aspekte. So werden den ‚störenden' Momenten häufig ironische oder humoristische Elemente zur Seite gestellt. Sailstorfers Wahl der Titel liefert diesbezüglich einen prägnanten Hinweis. *Heimatlied* zum Beispiel lässt vielschichtige Assoziationen entstehen. So kommen einem zum Beispiel Heimatfilme aus den fünfziger Jahren in den Sinn, in denen sich zwischen scheinbar glücklichen, in Trachten gekleideten, Menschen, die sich vor allem durch Gesang verständigen, eine dramatische Geschichte entfaltet. Sicherlich schwingen in dem Wort Heimat kitschige und nostalgische Konnotationen mit. Als Titel für ein behelfsmäßiges Haus aus wiederverwerteten Teilen von Wohnmobilen, das für einen begrenzten Zeitraum inmitten einer ordentlichen deutschen Landschaft steht, ist *Heimatlied* ein wunderbar zynischer Verweis auf die deutsche Gesellschaft und Kultur der Gegenwart.

Wohnen mit Verkehrsanbindung funktioniert auf ähnliche Weise. Der Titel liefert eine verkürzte, jedoch gelungene Beschreibung dessen, was dargestellt wird, und bringt gleichzeitig die Absurdität der Situation zum Ausdruck. Sailstorfers Titel verstricken den Betrachter in ein Spiel, in dem es darum geht, das komplizierte Geflecht von Realität, Vorstellung und Annahmen zu entwirren. Im Titel *3 Ster mit Ausblick* (2002) beispielsweise verbindet Sailstorfer einen Terminus technicus mit dem romantischen Begriff *Ausblick*, wie man ihn vielleicht mit Casper David Friedrich assoziieren würde. Sailstorfer erklärt die etymologische Herkunft des Begriffes *Ster*: „*Ster* kommt aus der bayerischen Umgangssprache und bedeutet 1m x 1m x 1m Holz. 3 *Ster* sind 3 x 1m x 1m x 1m Holz. Die Menge an Holz, die für den Bau der Hütte aufgewendet wurde."[9] Mit *Ausblick* soll der panoramische Blick in eine reizvolle, häufig abgelegene, landschaftliche Szenerie suggeriert werden. Wie paradox dieser Titel eigentlich ist, werden wir noch sehen.

3 Ster mit Ausblick ist eine kurze Videoarbeit (1' 40") in Zusammenarbeit mit Jürgen Heinert.[10] Wie bei vielen von Sailstorfers Transformationen, steht auch hier das

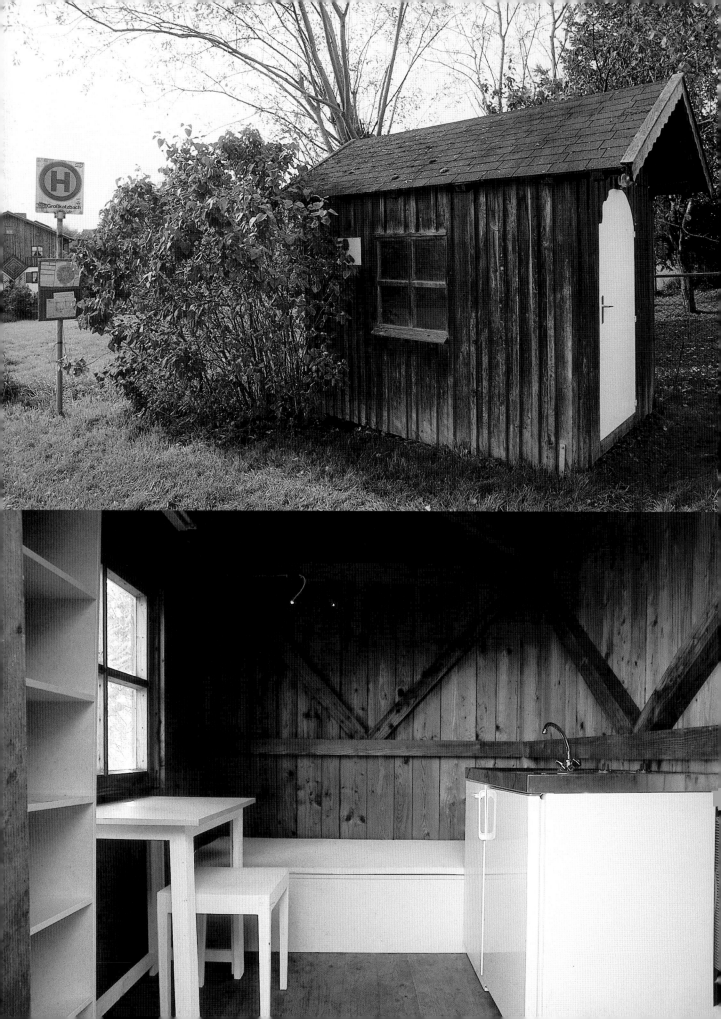

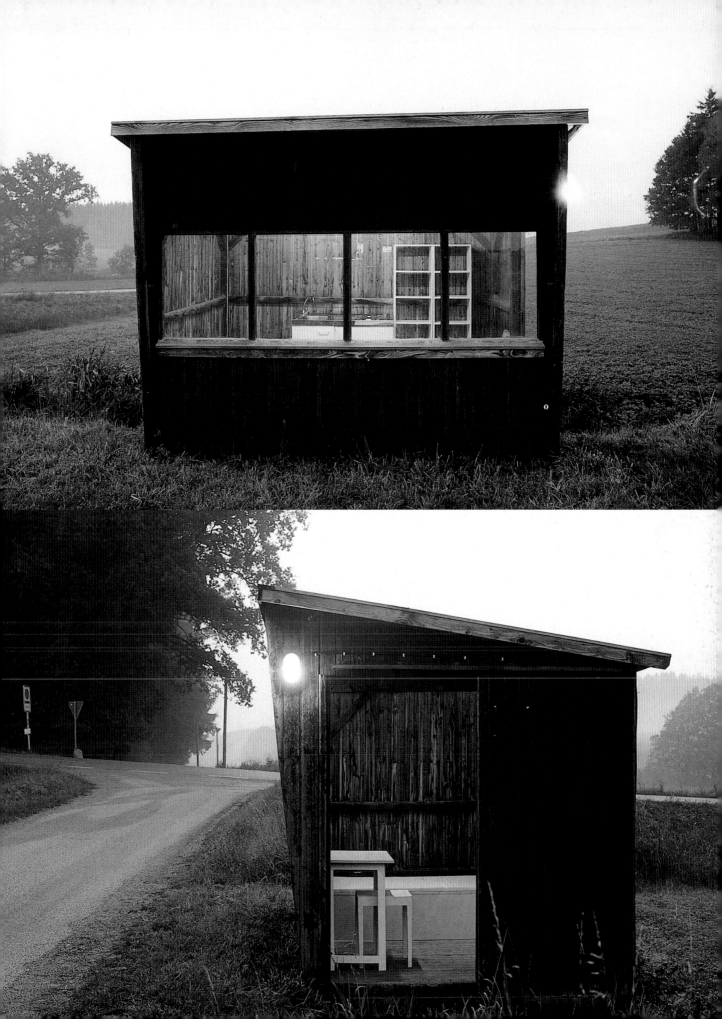

Haus im Mittelpunkt. Das Video zeigt eine Holzhütte, die sich augenscheinlich selbst konsumiert und nach und nach in Nichts auflöst, da ihre Bauteile in dem internen Holzofen verbrannt werden. Die kleine Hütte, die Sailstorfer einem Bauern aus der Nähe seines Heimatdorfes abgekauft hatte, steht inmitten einer für Süddeutschland so charakteristischen Landschaft. Sailstorfer und Heinert dokumentieren diese architektonische Selbstzerstörung über den Verlauf eines ganzen Tages. Eine in der Morgendämmerung noch intakte Holzhütte verwandelt sich schließlich in einen einsamen, noch schwelenden Ofen in der Abenddämmerung.

Mit spielerischer Ironie verändern die Künstler den Sinn des Holzofens. Er dient nicht länger als materieller und geistiger Mittelpunkt des Hauses, vielmehr wird er zum inneren Aggressor, der die Grundfesten seiner eigenen Häuslichkeit zerstört. Sailstorfer und Heinerts Verwandlung spricht dem Ofen die metaphorische Rolle des Nährenden ab. Im Gegenteil, die Tatsache, dass er mit seiner unmittelbaren Umgebung gefüttert wird, führt zu dessen Aufhebung. Anstatt einer schönen Aussicht, bilden die 3 Ster – als eine bestimmte Menge Holz – nicht länger eine Hütte, sondern werden auf ihren elementarsten Verwendungszweck reduziert und als Brennholz für den Ofen benutzt.

Es ist bezeichnend, dass die Künstler bei der Demontage des Hauses niemals ins Blickfeld geraten. Zu Beginn ist nicht klar, was eigentlich passiert. Es dauert vielmehr eine Weile bis sich der Zusammenhang zwischen der sich sukzessiv reduzierenden Hütte und dem stärker werdenden Rauch, der aus dem Ofenrohr aufsteigt, offenbart. Die Zerstörung der Hütte folgt keinem intrinsischen Prinzip. Sailstorfer und Heinert schneiden das Holz willkürlich aus den vier Seiten oder dem Dach der Hütte. Diese Strategie spiegelt den natürlichen Verfallsprozess. Der Betrachter wird damit Zeuge eines paradoxen Unterfangens: es entsteht der Anschein als würde das Haus ein Eigenleben entwickeln und autonom agieren. Sailstorfer und Heinert verstärken diesen Eindruck, indem sie den Prozess der Demolierung, der in Wirklichkeit einen ganzen Tag in Anspruch nahm, zeitlich auf weniger als zwei Minuten verdichten. Einige ihrer Einschnitte sind jedoch zu präzise und sauber, um das Resultat einer natürlichen Zersetzung zu sein. Dieser Bruch verwirrt den Betrachter abermals. Die begleitende Geräuschkulisse steigert dieses Gefühl.

Sailstorfer und Heinert kontrastieren das fröhliche Gezwitscher von Vögeln mit den knisternden Geräuschen des Ofens, der sein ehemaliges Zuhause verdaut.

Sailstorfers skulpturale Eingriffe sind transformative Aktionen. Sie bewegen sich zwischen dem Skulpturalen und der Performance. Aber in Sailstorfers Fall kann die Performance nicht im herkömmlichen Sinne verstanden werden, da den Arbeiten oftmals das Publikum als auch die handelnde Person fehlt. In *3 Ster mit Ausblick* zum Beispiel, haben sich Sailstorfer und Heinert bewusst aus dem Videomaterial herausgeschnitten. Weder sind die Künstler sichtbar beim Abbau der Holzhütte, noch haben sie Interesse, die körperliche Anstrengung und die Unordnung zu zeigen, die die Zerstörung der Hütte mit sich bringt. Ganz im Gegenteil, sie bieten dem Betrachter nur saubere Bilder. Die Kraftanstrengung wird ausgespart. Dies wird in den Fotografien mit demselben Titel, die Sailstorfer und Heinert neben dem Film gemacht haben, besonders deutlich. Jede einzelne der zehn Aufnahmen stellt einen menschenleeren, nahezu erstarrten Moment in der stufenweise Destruktion der Hütte dar. Die visuelle Subtraktion führt, wie bei so vielen von Sailstorfers Arbeiten, zu einem Gefühl der Irritation.

Wenn wir jedoch zum Aspekt der Performance zurückkommen, muss man sich fragen, wo eigentlich das Publikum bleibt? Sailstorfers Projekte gleichen oft heimlichen Unterfangen, die im Schutz der Nacht vonstatten gehen. Obwohl Sailstorfers Arbeitsaufwand nicht zu unterschätzen ist – man bedenke, was es bedeutet vier Wohnwagen auseinanderzunehmen und sie zu einem Haus zusammenzubauen – sehen wir häufig nur die letzte Etappe der Metamorphose.[11] Zudem wählt Sailstorfer oft entlegene Plätze als Ortung, oder vielleicht eher als Dislokation, für seine verwandelten Objekte. Das bedeutet, dass nur wenige Leute die skulpturalen Unternehmungen vor Ort mitverfolgen können. Deshalb begegnen dem Betrachter seine Arbeiten häufig in anderen materiellen Manifestationen. 2004 übertrug Sailstorfer *Heimatlied* in eine Dia-Installation. Der Diaprojektor steht auf einem kleinen Einbautisch – ein Überbleibsel aus einem der vier zu einem einzigen Haus fusionierten Wohnwagen. Die acht Dias zeigen verschiedene Perspektiven (Inneres, Äußeres, Tag und Nacht) der abgeschlossenen Verwandlung. In *3 Ster mit Ausblick*, der Schwarz-Weiß-Fotoserie von *Wohnen mit Verkehrsanbindung*, oder *Heimat-*

Seite page 36
WOHNEN MIT VERKEHRSANBINDUNG, URTLFING
2001

Seite page 37
WOHNEN MIT VERKEHRSANBINDUNG, ANZING / WILNHAM
2001

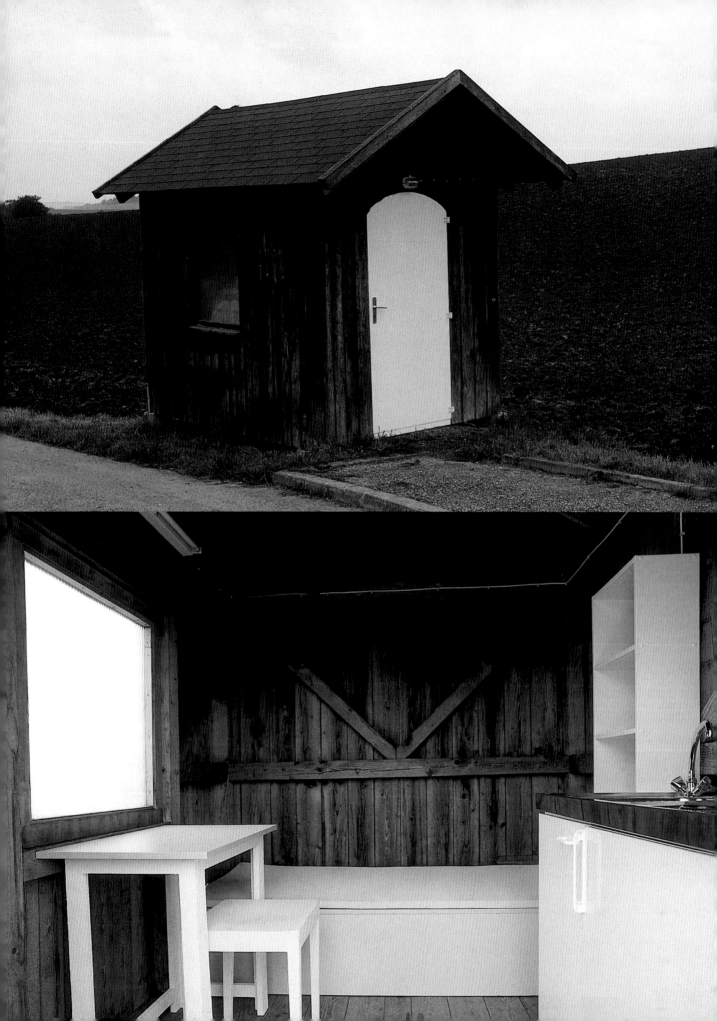

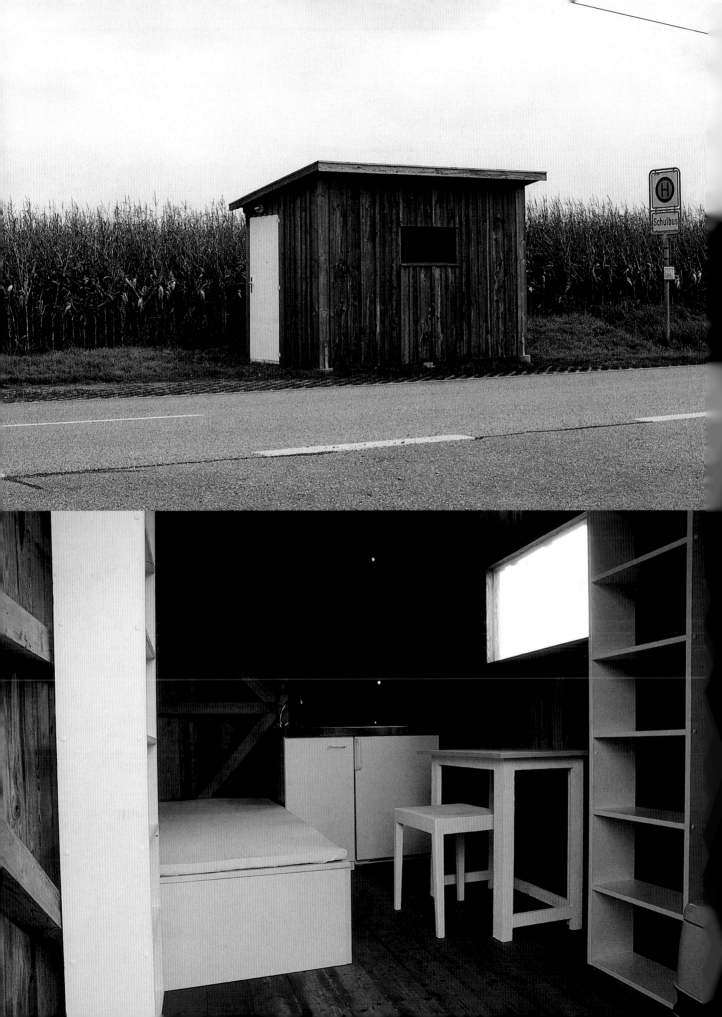

lied behandelt Sailstorfer diese Dokumentationsformen auf eine Weise, die der ähnelt, wie er über die ursprünglichen Objekte denkt. Sie sind nicht auf eine spezifische Erscheinungsform beschränkt, sondern für Veränderungen und Manipulationen offen.

Auch wenn die unterschiedlichen Etappen der Transformation nicht immer transparent sind, betont Sailstorfer sein narratives Interesse: „Ich möchte, dass der ganze Prozess von A bis B im endgültigen Objekt deutlich zu erkennen ist, um eine Art Zeitleiste der Geschichte des Objekts zu kreieren."[12] Dieser Handlungsstrang wird jedoch nicht ausschließlich durch das konstruiert, was man tatsächlich sieht, sondern nährt sich auch an den Implikationen, die die verwendeten Materialien liefern. Sailstorfer ist überzeugt, dass jedes Ding nicht nur eine bestimmte Geschichte erzählt, sondern dass selbst die isolierten, zerlegten Bestandteile unaufhörlich auf ihre ursprüngliche Bedeutung zurückverweisen.

Herterichstraße 119 (2001) reflektiert diesen speziellen Zugang, der die evidente Bedeutung des Originals mit dem umstrukturierten neuen Objekt kontrastiert. Diese Installation besteht aus zwei Komponenten: einem Sofa, das aus den Überbleibseln eines abgerissenen Einfamilienhauses besteht, und einem gerahmten Foto des gleichen Hauses vor dessen Abriss. Sailstorfer konvertiert verschiedene Elemente, wie eine Tür oder eine farbige Holzpaneele, die vormals einen Teil der Hausfassade bildeten, zu einem großen Sofa. Die Umwandlung des Hauses in eine Couch erfordert keine exogenen Teile, sondern bleibt auf das eigene System beschränkt. So werden zum Beispiel die Backsteine des Hauses zu Sofabeinen und so weiter. Insofern stellt diese formale Neuinterpretation eine Analogie zum selbstverzehrenden Wesen von *3 Ster mit Ausblick* dar.

Im Ausstellungskontext positioniert Sailstorfer das Foto des intakten Hauses direkt über dem Sofa und umreißt damit eine humorvolle häusliche Szene. Aufgrund der impliziten Bezüge bilden die zwei Komponenten eine erzählerische Einheit, indem das Vorher und Nachher immerzu aufeinander verweisen. Obwohl diese Anspielungen einen wesentlichen Teil der Arbeit präsentieren, steht *Herterichstrasse 119* dennoch für sich selbst und besitzt seine eigene Agenda. Sailstorfers Erzählungen sind häufig paradox und absurd. Sie vermischen scheinbar bezuglose Ebenen und bewirken eine Inkongruenz des-

sen, was erwartet wird und was letztendlich passiert. Dementsprechend ist das Un-
erwartete immer präsent. In Sailstorfers Objekten überschneiden sich divergierende Be-
deutungen, die nichtsdestotrotz nebeneinander bestehen können. Die Materialien sind
immer der Schlüssel für das Verständnis der Handlung: wir müssen sie wie ein Puzzle
zusammenfügen, um das vollständige Bild zu erhalten.

Hier ist die Wurzel von Sailstorfers Kreislauf des Auseinandernehmens und Neu-
zusammenfügens – das Grundprinzip seiner Transformationen – zu finden. Laut Sails-
torfer „ist die Dekonstruktion genauso wichtig wie die Konstruktion eines Objekts. Es ist
der optimale Zeitpunkt, das Material von allen Seiten zu verstehen und über die Form und
Details der Skulptur nachzudenken."[13] Im Zerlegen eines Wohnwagens zum Beispiel,
kommt Sailstorfer den spezifischen Eigenschaften des Objekts näher. Überdies erlaubt
ihm diese Information einen Schritt weiter zu gehen und etwas Neues zu schaffen. Aus
diesem Grund ist für Sailstorfer die Destruktion der Kernpunkt für jede neue kreative
Arbeit. „Wenn man den Prozess mit dem Malen eines Bildes vergleicht" so Sailstorfer „so
steht die Dekonstruktion für die Grundierung der Leinwand."[14] Sailstorfer ist nicht nur an
einer bloßen Umwandlung des Alltagsobjekts in ein ästhetisches Objekt interessiert, viel-
mehr stellt er das Original auf die Probe, um den ihm innewohnenden Mechanismus zu
verstehen. Es ist weniger die Faszination an der zerstörerischen Geste, die Sailstorfer
dazu bringt, ein Objekt zu zerlegen, sondern der Glaube an einen kontinuierlichen und
iterativen Zyklus von Demontage und Remontage.

In vielerlei Hinsicht kann Sailstorfers Arbeit mit der skulpturalen Methode von
Peter Fischli und David Weiss verglichen werden. In seinem Buch über die Schweizer
Künstler, hat der Kunsthistoriker Patrick Frey die beiden, nicht nur aufgrund ihrer Wahl
des Materials (sehr elementar), sondern auch angesichts ihres unablässigen Bedürf-
nisses, ihre Umgebung stetig zu verwandeln, mit erfolgreichen Alchemisten verglichen.[15]
Fischli und Weiss' *Der Lauf der Dinge* (1985 – 1987) ist ein treffendes Beispiel für die-
sen Denkansatz. Für den 16-mm Farbfilm errichteten sie eine Art Moebius Schleife aus
den verschiedensten, mehr oder weniger miteinander verbundenen Elementen. Eine
dominoähnliche Kettenreaktion von beherrschtem Chaos erfolgt. Solch unberechenbare

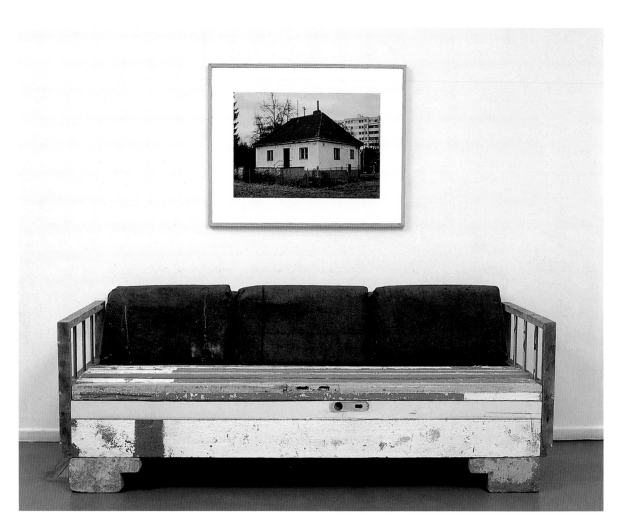

HERTERICHSTRASSE 119
2001

Elemente wie Feuer, Wasser oder Schwerkraft bilden den Impetus. *Der Lauf der Dinge* erzählt mit ultimativer Präzision die Geschichte der magischen und erstaunlichen Beziehung zwischen Ursache und Wirkung.

In Sailstorfers künstlerischer Praxis entdeckt man eine ähnliche Neigung. Mit pseudowissenschaftlicher Methodik und Akribie verändert er sein Ausgangsmaterial und führt es einer unerwarteten Verkörperung zu. Dennoch geht es ihm nicht darum, seine Quelle zu verschleiern: ein Alchemist in Ausbildung. Dementsprechend sind seine Verschiebungen in Form, Struktur und Charakter genauso absurd wie der Versuch, Blei in Gold zu verwandeln. Allzu oft können Sailstorfers Erfindungen als Scherz missverstanden werden. Tatsächlich ist seine Abrakadabra-Zauberei eine sanfte Ohrfeige gegen unser Konstrukt aus Überzeugungen, Annahmen und Erwartungen.

Dieser Gedanke verbindet sich mit seiner unaufhörlichen und ansteckenden Neugier, dem Wunsch die Welt zu erkunden. Sailstorfer ist ein inspirierter Bastler. Sein kindlicher Entdeckergeist kann als Vertrauen in die Macht des Spiels und der Fantasie interpretiert werden. Eines der erfolgreichsten „Alice-im-Wunderland" Projekte ist *D-IBRB* (2002). Für dieses Projekt verwandelte Sailstorfer ein Segelflugzeug in ein Baumhaus. Mit spielerischer Sensibilität wählt er das Unvermutete, indem er seine eigenen Parameter und Richtlinien kreiert. Warum sollte ein Flugzeug nicht auf einem Baum landen und sich zu einem Baumhaus verwandeln? Dies ist nur eines der vielen Beispiele, wie Sailstorfer seine Kunst einsetzt, um unsere verkrusteten Einstellungen zu kitzeln. Nichtsdestotrotz funktioniert *D-IBRBs* Metamorphose auf mehreren Ebenen. „Diese Arbeit" so erklärt Sailstorfer „beruht auf der Spannung zwischen der Katastrophe und dem Kinderspiel."[16]

Sailstorfers Schöpfungen bewegen sich oft zwischen Nützlichkeit und Sinnlosigkeit, vermitteln jedoch immer das sinnliche Vergnügen ihres eigenen Entstehungsprozesses. In seiner Arbeit versöhnt er, so scheint es, zwei auseinanderstrebende Prinzipien der Konstruktion. Das architektonische Paradigma ‚die Form folgt der Funktion' steht Seite an Seite mit der Ästhetik des ‚Everything goes'.[17] Mit einer bemerkenswerten Do-it-Yourself Haltung zwingt Sailstorfer die Funktionalität seiner verwandelten Objekte an ihre

Grenzen. Seine Arbeit schwebt zwischen der Anerkennung von Funktionsprinzipien und deren gleichzeitigen Zuspitzung bis zu dem Punkt, an dem sie am Ende überzogen und nutzlos werden. „Vertraute Nützlichkeit wird mit Humor in Nutzlosigkeit verwandelt" so der Kritiker Mark Gisbourne „oder anders gesagt: Bedeutung und Funktion werden somit in einen zweiten Nutzwert transponiert."[18] Durch seine Arbeiten beweist Sailstorfer, dass es nicht nur einen Weg gibt, über Dinge nachzudenken und dass eine simplistische Bewertung nach Bedeutung und Aussagekraft nicht immer funktioniert. Sailstorfers Kunst hinterfragt die Hierarchie der Werte und wendet sich gegen jegliche Kategorisierung. Wie zum Beispiel ist ein Sofa einzuordnen, dass aus den Teilen eines abgerissenen Hauses hergestellt wurde?

Sailstorfers künstlerische Verortungen verwandeln das Haus in ein ironisches Objekt. Sie erforschen die Instabilität kultureller Bedeutung. Dem Haus wird seine traditionelle Bedeutung genommen – seine Nützlichkeit – und es wird nun als ästhetisches, jedoch nicht länger funktionales Objekt mit alternativen Implikationen belegt. Sailstorfer attackiert, physisch und metaphorisch, die Funktion des Hauses und betont somit das labile Verhältnis von Form und Inhalt. Die Funktion eines Objekts und seine materiellen Manifestationen können, so Sailstorfer, lediglich in einem ständigen Fluss existieren. Seine skulpturalen Verwandlungen suggerieren flüchtige Momente, in denen das scheinbar Permanente vergänglich wird. So gesehen kann die Arbeit von Sailstorfer als Interpretation seines Mottos verstanden werden, dass nichts verschwindet, sondern nur zu etwas Anderem wird.

Simone Subal

1 Die exakten Maße sind 375 x 410 x 360 cm.

2 Dies ist eine interessante Anspielung auf Dan Grahams *Homes for America* Projekt. In seinem Text über Vorstadthäuser hebt auch er die Abgrenzung dieser Häuser von ihrer Umgebung hervor: „Developments stand in an altered relationship to their environment…the houses needn't adapt to or attempt to withstand nature. There is no organic unity connecting the land site and the home. Both are without roots– separate parts in a larger, pre-determined synthetic order." Dan Graham, „Homes for America: Early 20th Century Possessable House to the Quasi-Discrete Cell of ‚66," *Arts Magazine* (Dezember 1966 – Januar 1967): 22.

3 Ivanmaria Vele, „Boiler's Choice: Michael Sailstorfer," *Boiler Magazine, Nr.* 3 (November 2003): 11.

4 Neben des weiter unten besprochenen *Bad Dream House*, sind *Instant House* (1980), *Mobile Home* (1980) und *House of Cars* (1983) zu erwähnen.

5 Vito Acconci, „Homebodies," in *Vito Acconci: The City Inside Us*, ed. Peter Noever (Wien: Museum für Angewandte Kunst, 1993), 90.

6 Vito Acconci, „Projections of Home," in *Vito Acconci*, ed. Amnon Barzell (Prato, Italien: Museo d'Arte Contemporanea Luigi Pecci, 1991), 126.

7 Mark Gisbourne, „Michael Sailstorfer: Email conversation 18 May, 2004," in *Manifesta 5: European Biennial of Contemporary Art* (San Sebastian, Spanien: Centro Internacional de Cultura Contemporanea, 2004), 189.

8 Diese vier kleinen Orte sind alle in der Nähe von Vilsbiburg, Sailstorfers Heimatort.

9 Michael Sailstorfer in einer E-mail Konversation, 13. Oktober 2004.

10 Jürgen Heinert wurde 1970 in Syktywkar, Russland geboren. Er studierte an der Akademie der Bildenden Künste München (Abschluss 2001). Heinert hat verschiedene Stipendien erhalten, unter anderem einen dreimonatigen Aufenthalt an der Parsons School of Design, New York in 1998 und das Stipendium des DAAD für die Niederlande in 2001. Er hat an einer Reihe von Ausstellungen teilgenommen, die meisten davon in Deutschland: *junger westen* in der Kunsthalle Recklinghausen, 2001; *Kraft und Magie* während der Oberbayerischen Kulturtage, Altötting, 2001; *Wir, hier!* in der lothringer 13/halle, München, 2003; *Go Johnny Go* in der Kunsthalle Wien, Österreich, 2003 – 2004.

11 *3 Ster mit Ausblick* kann hier als Ausnahme betrachtet werden. Aber nichtsdestotrotz sind, wie bereits oben erwähnt, die einzelnen Aufnahmen oder die Rahmen deutlich voneinander abgegrenzt.

12 Gisbourne, 189.

13 Vele, 11.

14 Vele, 12.

15 Patrick Frey, *Ein ruheloses Universum: Zu den Gemeinsamen Arbeiten von Peter Fischli und David Weiss* (Basel: Kunsthalle Basel, 1985), 16. Diese Analogie kam auch in Belinda Grace Gardners Text über Sailstorfers künstlerische Praxis zur Sprache, in der sie diese mit „architektonischer Alchemie" in Verbindung bringt. Belinda Grace Gardner, „Im Mercedes zu den Sternen: Michael Sailstorfer Macht die Skulptur Mobil," Kunstzeitung no. 98 (Oktober 2004): 19.

16 Gisbourne, 189.

17 Ich habe diesen Gedanken aus Patrick Freys Analyse der Fischli und Weiss Serie *Stiller Nachmittag* adaptiert, 1984 – 85, oft als *Equilibres* (Balances) Serie bezeichnet .

18 Mark Gisbourne, „Michael Sailstorfer 2003," http://www.galeriemarkusrichter.de/eng/sailstorfer/sailstorfer_eng_texte.htm - up, March 17, 2005.

19 Gisbourne, „Michael Sailstorfer: Email conversation 18 May 2004," 190.

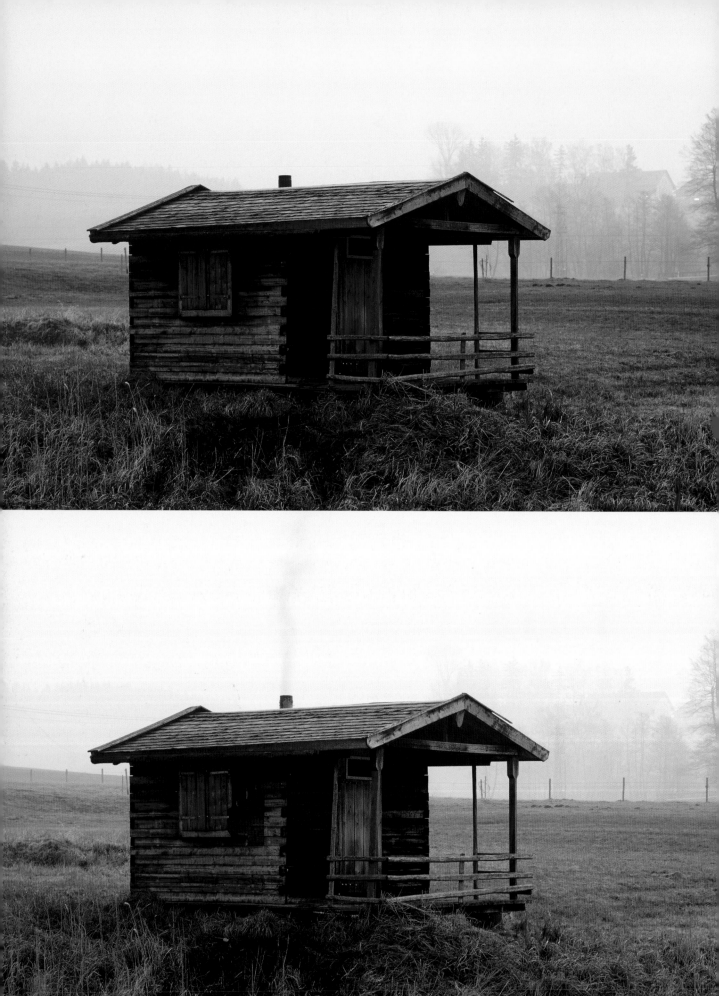

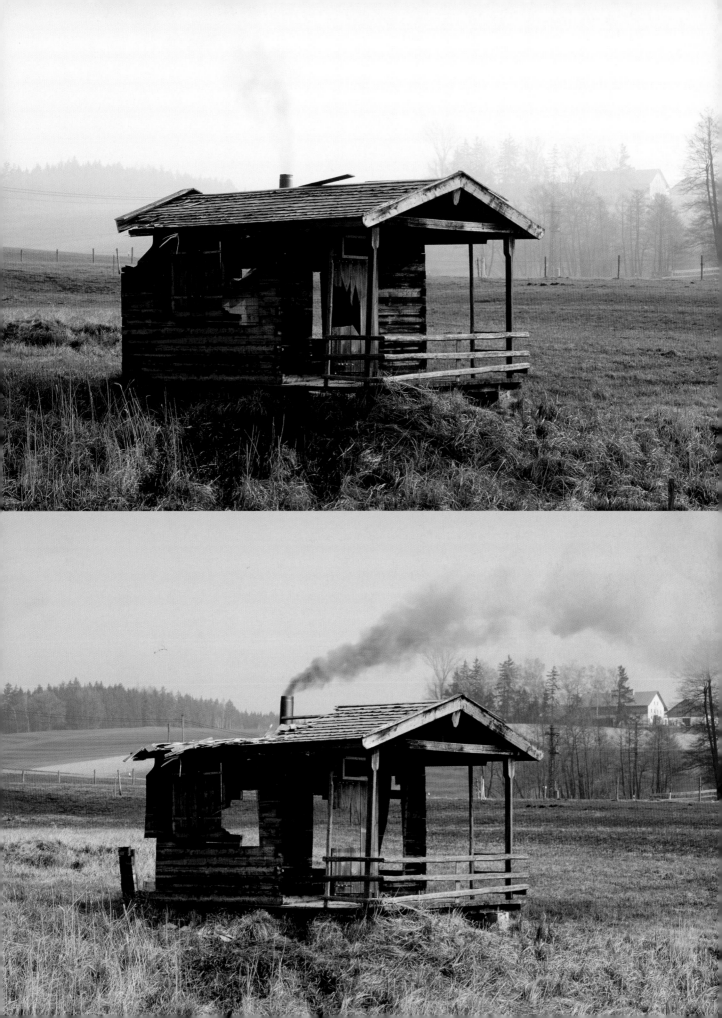

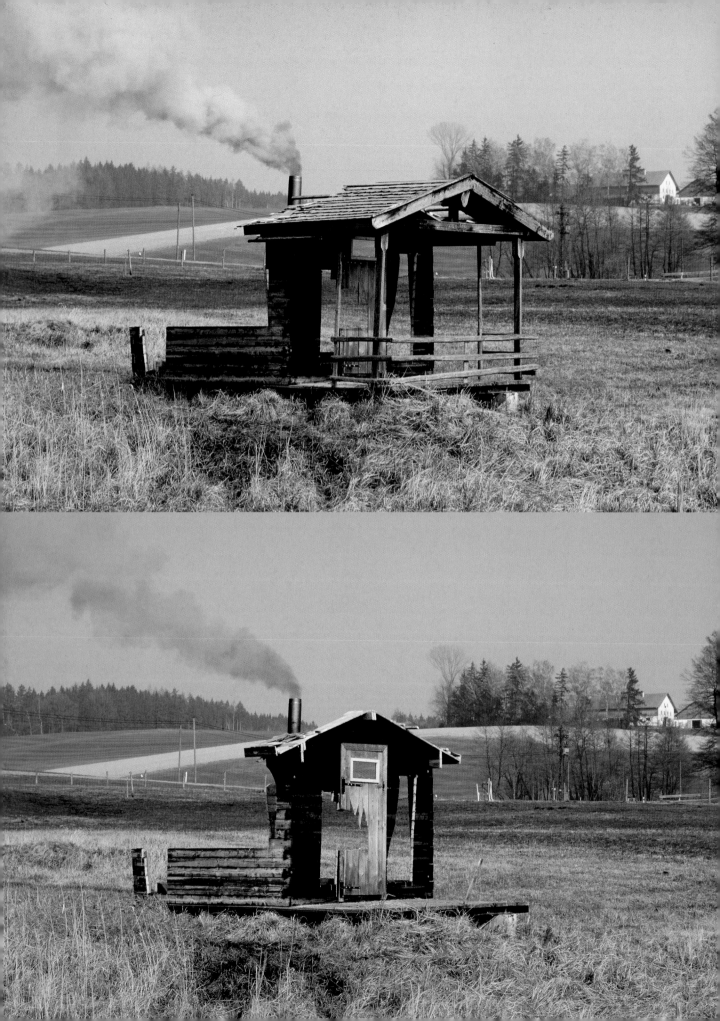

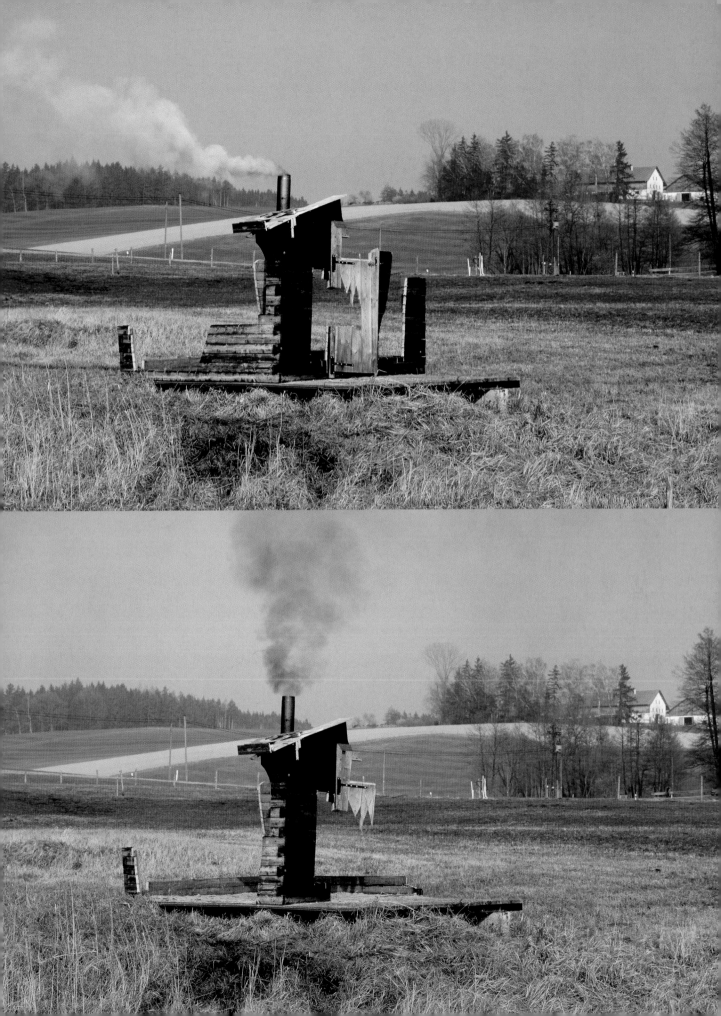

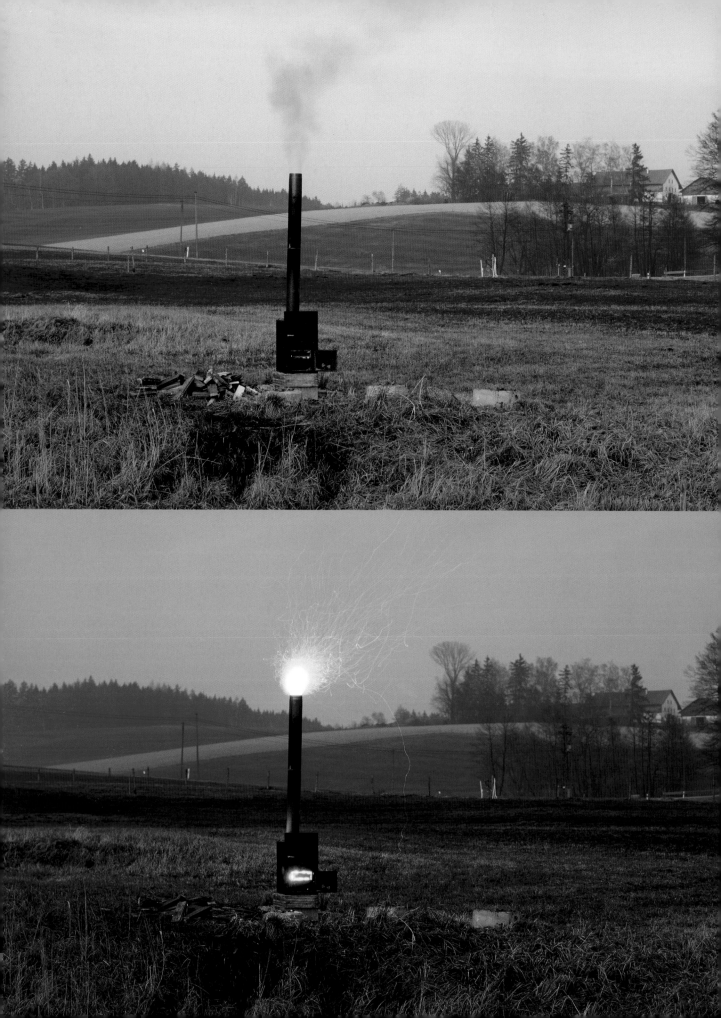

Michael Sailstorfer's experiments in alchemy

"I like the idea of creating
something new by taking something away"
Michael Sailstorfer

Throughout Sailstorfer's young career, several recurring themes can be identified. Frequently, he plays with the implications of travel and mobility, and sets them against the understanding of having a place, of being at home. Sailstorfer examines these nomadic tendencies – represented through airplanes, cars and caravans – by transforming them into fixed domestic shelters such as a cabin or house.

For example, in *Heimatlied* (Homeland song, 2001) the artist dismantles four mobile homes. He then reassembles them into one single house that is more than four meters in length.[1] This fully functional house, equipped with electricity and water, rests in the German countryside, surrounded by nothing more than fields and a few scattered houses. The exterior is reminiscent of a fastidiously made patch-work-blanket in which each component still refers to its former life. Sailstorfer, here, cancels the mobility of the mobile homes. Still, the viewer can nonetheless piece together the individual segments and recreate in their mind the four different caravans. Notably, the parts are not detached from their original function: the door remains a door, the window a window. Indeed, Sailstorfer turns the objects into modules. Despite the slightly banged up materials, he handles the construction with the utmost precision. He treats every element with impressive craftsmanship, merging them into a seemingly organic apparatus.

Nevertheless, the interior creates a slightly disorienting and surreal feeling: nothing seems quite right. The new built-in units, without any trace of their protecting environments appear displaced, and the unavoidable mix of styles, patterns, and surface materials only add to the peculiar circumstances. For instance, the windows are neither aligned nor have exactly the same shape, which confounds one's sense perception. Quite often, these digressions are minor. Therefore, the realization of these spatial inconstancies comes belated. It is important to note, however, that Sailstorfer does not clutter up the interior, but keeps it neat – devoid of any traces of active living such as random toys,

books, or dishes. *Heimatlied* seems like a stage set for an uncanny play about to unfold. This feeling is echoed in the house's specific placement in the countryside. Sailstorfer is not interested in depicting the idyllic and sublime of nature, but instead portrays a typical German landscape: undulating hills divided into small parcels of farmland. We are strangely never able to actually see anybody, even though the fields, roads, and manmade paths constantly evoke the presence of people. The juxtaposition of this very particular banal countryside and Sailstorfer's incongruous house-construction adds to the odd character of the situation and emphasizes the sense of estrangement.[2] In fact, Sailstorfer thinks of his installations as points of discomfort: "Sometimes they [the works] are relocated in the countryside where they seem to the locals like an irritating picture."[3]

Sailstorfer's attempt to discombobulate the viewer can be compared to Vito Acconci's early architecture-referenced work. In this body of work from the early to mid 1980s, Acconci investigated the spatial and psychological relationship between architecture and the body.[4] Acconci comments on his concept of the house in his text *Home-Bodies: An Introduction to my Work 1984–85*: "If the house makes you cozy, if you can snuggle into it, then you are lost in the past and stabilization; but if the house makes you itch, if you do a double-take, then you snap out of the present, you have time to think of the future and change."[5] Sailstorfer's itchy *Heimatlied* snaps one out of the present in a similar way to Acconci's *Bad Dream House* (1983). Acconci overturns the structure of a house by merging three constructed houses into one multi-part dwelling. Two tilted brick houses, propped up against each other, build the base for a far from stable glass house. Acconci connects these three houses in order to create a disquieting interior space.

Acconci deliberately upsets the viewer's orientation and, in so doing, reverses the possibility of perceiving the structure as a whole entity. Thus, he paints the brick houses' ceilings, which now function as floors in sky blue; and the original floors, now angled ceilings, are colored grass green. Acconci's *Bad Dream House* can be seen as an antithesis of the American dream: it rejects any sense of security or solidity of the private home. Instead, the *Bad Dream House,* by spatially dislocating the viewer, questions the validity of these concepts so vital to the American way of life.

Sailstorfer translates some of Acconci's ideas into a German context. While Acconci's installations are embedded in an urban scenario, Sailstorfer's *Heimatlied* transposes the questions of habituation to the Bavarian countryside. Here, the public's immediate response and interaction with Acconci's piece is traded for a physical dislocation, which triggers an ironic and surreal undertone. This surreal feeling is contrasted (and at the same time enhanced) by the authenticity of the dismantled mobile homes. These caravans had a prior life, and, unlike Acconci's on-site constructions, the four different stories of each mobile home come together in their subdued mobility.

Both artists regard the altered structure of the house as an appropriate vehicle to express their artistic ideas. "Some of us," Acconci claims, "[...] choose the house as a prototype because it ties in with people's common knowledge and ordinary usage; since the house can be assumed as a place to be in and not be met with resistances as 'art', it can be used, as a matter of course, as an occasion for social interaction and cultural reconsideration."[6] Sailstorfer reverberates this understanding by emphasizing his inclination to work with familiar objects: "I want my work to be close to life, if you like parallel to my life, that's why I decided to start to work with familiar things that surround me."[7] Yet, both *Heimatlied* and *Bad Dream House* play with this all too easy possibility of recognition, which is followed and subsequently inverted by unsettling moments of disorientation.

Wohnen mit Verkehrsanbindung (Living with transport connection, 2001) combines these previously discussed aspects and is one of Sailstorfer's numerous sculptural interventions in the public realm – but this time, in four small towns in Southern Germany; Anzing, Großkatzbach, Oberkorb, and Urtlfting.[8] Sailstorfer altered the interior of four bus shelters, equipping them with 'survival' furniture. The work's description lists components such as bus stop, door, electricity, water, kitchen, bed, table, chair, and lightening. Even a toilet found its proper place. Everything is functional and ready to use. The furniture is minimal in its stripped down language of geometrical lines, and the shapes follow the construction methods and the actual function of the individual objects. Once again, Sailstorfer plays with the connotation of the traveler, but subtracts the glamour and translates it into a particular and realistic circumstance: the endless wait for the

bus to arrive. In these tiny towns in Southern Germany, the bus is a connection to the world. Therefore, Sailstorfer attempts to not only give shelter to the commuter, but also transform this place of wasted time into something useful.

While Sailstorfer maximizes the functionality of these bus shelters, he, at the same time, ironically scrutinizes the notion of mobility. These bus stops are not designed for an exhibition context, but present a local reality. As a public place, these waiting areas have conditioned certain behavioral patterns, which are challenged by Sailstorfer's alterations. What a bolt from the blue to discover, instead of the standardized waiting benches, a condensed but functional living ensemble, which, nevertheless, has to be shared with other commuters. This causes a displacement within the familiar.

Sailstorfer decided to turn these short-lived installations into a series of eight black and white photographs. Shot at dusk, partially lit, these bus shelters gain an eerie quality. They seem lost and abandoned. Instead of a safe-haven or a place of comfort, the interiors resemble an emptied out movie set. The rough and weathered wood contrasts sharply with the clinical white furniture. Similar to the interior of the *Heimatlied* house, all traces of habitation have been erased. Or, perhaps they have never been there in the first place? *Wohnen mit Verkehrsanbindung* is Sailstorfer's most reserved and somber work, in which the initial playfulness is challenged by his particular use of the black and white photographs.

In fact, in Sailstorfer's work we often find two or more counteracting sides. For example, these moments of interferences are continuously juxtaposed with ironic and humorous elements. Sailstorfer's choice of titles is certainly an indication. *Heimatlied's* literal translation, as I suggested earlier, is homeland song. This word is full of multi-layered associations. *Heimat*-movies from the 1950s pop up in my mind. Here, drama enfolds between seemingly happy people, dressed in folk costumes, who mainly communicate through theatrical singing. Certainly, the word is loaded with both kitschy and conservative suppositions of nostalgia. As a title for a temporary makeshift house that recycles the dismantled parts of mobile homes set in the middle of a tidy German landscape, *Heimatlied* is a beautifully cynical statement on contemporary German society and culture.

Wohnen mit Verkehrsanbindung works along similar lines. This title offers an abbreviated but functional description of what is represented. It also suggests the absurdity of this situation. Indeed, his titles draw the viewer into a game of unraveling reality, imagination, and assumptions. The title *3 Ster mit Ausblick* (3 Steres with a view, 2002), on the other hand, juxtaposes technical vocabulary with a romantic sentiment one might find in Casper David Friedrich. Sailstorfer describes the etymological specifics of the word *Ster*: "*Ster* is a Bavarian slang and means 1m x 1m x 1m of wood. 3 *Ster* are 3 x 1m x 1m x 1m of wood. The amount of wood they used to build the cabin."[9] *Mit Ausblick* translates as "with a view." But it is not any kind of view, but implies a panoramic outlook into delightful, often remote scenery. We will see how paradoxical this title proves to be.

3 Ster mit Ausblick is a short video collaboration (1' 40") with Jürgen Heinert.[10] As in so many of Sailstorfer's sculptural transformations, the house takes center stage. The video records a wooden country house consuming itself by gradually burning its structural parts in its own wood stove. This little cabin, which the artists bought from a farmer close to Sailstorfer's Bavarian hometown, rests in a typical southern German landscape. Sailstorfer and Heinert track this architectural self-destruction over the span of an entire day. The result is the transformation of an intact wooden house at dawn into an isolated and smoldering stove at dusk.

With playful irony, the artists change the meaning of the wood-burning stove. It no longer acts as the material and spiritual center of the house, but instead, becomes the internal aggressor that attacks the very foundations of its own domesticity. Sailstorfer and Heinert's transformation denies the stove the role as a literal and metaphorical place of nourishment. On the contrary, its own self-nourishment leads to self-annihilation. Instead of offering a nice view, the *3 Ster* – this certain amount of wood – no longer constitutes the cabin, but is now turned into its most basic usage: as food for the stove.

It is significant that the artists are never visible in the act of dismantling the house. In the beginning, it is not quite clear what is transpiring. Indeed, it takes a while to understand the relationship between the sequentially minimized house and the increased

smoke dispersing from the stove's chimney. The destruction of the house does not follow any intrinsic logic. Sailstorfer and Heinert seem to randomly cut into the house's four sides and roof. This strategy mirrors the natural decaying process. As a consequence, the viewer witnesses a paradoxical endeavor: the house appears animated, acting in its own right. Sailstorfer and Heinert emphasize this notion by condensing the process of destruction, which in real time covered the full length of a day, into less than two minutes. Nevertheless, some of the cuts are clearly too precise and clean to be a result of natural decomposition. This, once again, confounds the viewer. The sound component adds to this feeling. Sailstorfer and Heinert contrast the cheerful chirping of nearby birds with the smoldering noises of the stove digesting its former home.

Sailstorfer's sculptural interventions are transformative actions. They lie somewhere between performance and sculpture. But in Sailstorfer's case, performance cannot be understood in the traditional sense, as the works often lack both the performer and the audience. For example in *3 Ster mit Ausblick*, Sailstorfer and Heinert remove themselves from the video. They are never visible in taking apart the little wood cabin. They are not interested in showing the messiness and physical exertions dismantling the house entails. Instead, they choose to offer the viewer clean images. The physical labor is obscured. This approach becomes even more evident in the series of photographs Sailstorfer and Heinert created alongside the film. In these ten shots, the gradual, but explicit, destruction of the house and the significant changes in the surrounding nature – from dawn till late at night— turn each photo into a distinct, individual image. This visual subtraction leads, as previously seen in other pieces such as *Heimatlied*, to a feeling of disorientation.

Coming back to the idea of performance: where then is the audience? Often Sailstorfer's projects resemble furtive, under-the-cover of night undertakings. Although Sailstorfer invests a tremendous amount of labor – just think of what it takes to take apart four mobile homes and transform them into one house – we often only see the last stage of this metamorphosis.[11] In addition, Sailstorfer frequently picks the remote German countryside as location, or should we say dislocation, for his transformed objects. This means that only a few people can witness these sculptural endeavors on site. Therefore,

the viewer comes across these works in altered material manifestations. In 2004, Sailstorfer turned *Heimatlied* into a slide installation. The slide projector rests on a small built-in table – a remnant of one of the mobile homes Sailstorfer transformed into a house. The eight slides offer various perspectives (interior, exterior, day and night) of the completed metamorphosis. In *3 Ster mit Ausblick*, the black and white photo series of *Wohnen mit Verkehranbindung*, or *Heimatlied*, Sailstorfer treats these forms of documentation in a similar way to how he thinks about the original objects. They are not limited to one singular appearance but open for alterations and manipulations.

Although the different stages of the transformation are not always immediately visible, Sailstorfer attempts to generate a narrative: "I want the whole process from A to B to be clearly visible in the final piece, to create a kind of timeline of a story."[12] Yet, this plot is not exclusively constructed by what you actually see, but also by the implications of the used materials. Sailstorfer is convinced that every object tells a story and that even its dismantled parts refer back to its original meaning.

This specific approach, which contrasts the apparent meaning of the original with the restructured new object, becomes evident in *Herterichstraße 119* (2001). This installation comprises two components: a sofa made out of the remains of a demolished single family house and a framed photograph of this same house prior to its disassembly. Sailstorfer transforms several elements, such as a door and colored wood panels, which formed part of the house's exterior, into a large couch. This transmutation from an intact house into a couch does not depend on any exterior parts, but remains within its own system. For instance, the bricks of the house generate the legs for the sofa, and so on. Thus, this reprocessing structure suggests an analogy to the self-consuming nature of *3 Ster mit Ausblick*.

In an exhibition context, Sailstorfer positions the photograph of the intact house right above the sofa, creating a humorous domestic scene. As a result of these implicit references, the two components create a narrative unity, bridging the before and after. Even though these allusions are an essential part of the piece, *Herterichstrasse 119* at the same time stands for itself and has its own agenda. The narratives Sailstorfer presents are

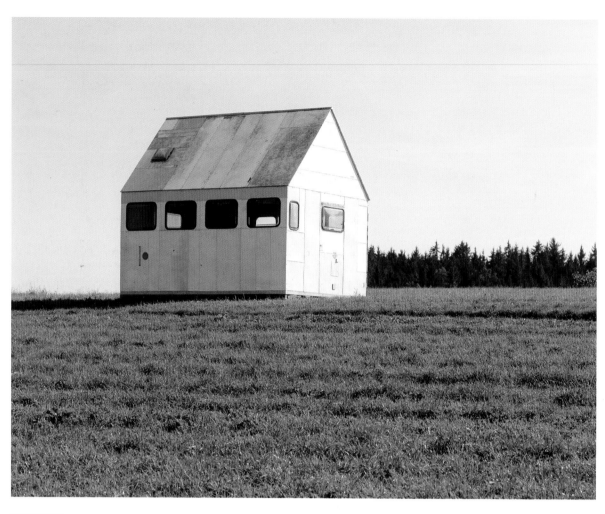

HEIMATLIED
2001

often paradoxical and absurd. They link several unrelated levels, allowing for an incongruity in what might be expected and what might actually occur. Therefore, the unanticipated is always present. In Sailstorfer's objects, different meanings can simultaneously coincide and coexist. The materials are always key to the understanding of the plot. They are the ones we have to put together, like a puzzle, in order to get the full picture.

It is here, where the foundation of this cycle of taking apart and reassembling – the core of Sailstorfer's sculptural transformations – can be found. According to Sailstorfer, "the deconstruction work is as important as the construction of an actual piece because it is the perfect time to know, to understand the material inside out and to think about the shape and the details of the sculpture."[13] It is in this dissecting of a mobile home, for example, in which Sailstorfer comes closer to the specific properties of the object. Moreover, this information allows him then to go one step further and to actually create something new. Therefore, according to Sailstorfer, destruction is key to any new creation. "If you compare the process with doing a painting," Sailstorfer states, "the deconstruction part might represent the grounding of the canvas."[14] Sailstorfer is not merely interested in a simple shift of the everyday object to an aesthetic one, but he wants to get closer to the original object in order to understand its intrinsic mechanism. It is not the simple destructive gesture that compels Sailstorfer to dismantle the object but the belief in a continuous cycle of destruction and reassembly.

In many ways, Sailstorfer's work can be equated with Peter Fischli and David Weiss' sculptural method. In his book on the Swiss artists, the art historian Patrick Frey compared the two with successful alchemists, not only because of their material choices (very basic) but also because of their obsessive urge to constantly transform their surroundings.[15] Fischli and Weiss' *Der Lauf der Dinge* (The Way Things Go, 1985–1987), is an apt example of this approach. In this 16-mm color film, they built a 100 feet looping structure that consists of various elements more or less connected to each other. A domino-like chain reaction of contained chaos ensues. This procession advances by means of such unpredictable elements as fire, water, or gravity. With ultimate precision, *Der Lauf der Dinge* tells the story of the magical and unpredictable relationship between cause and effect.

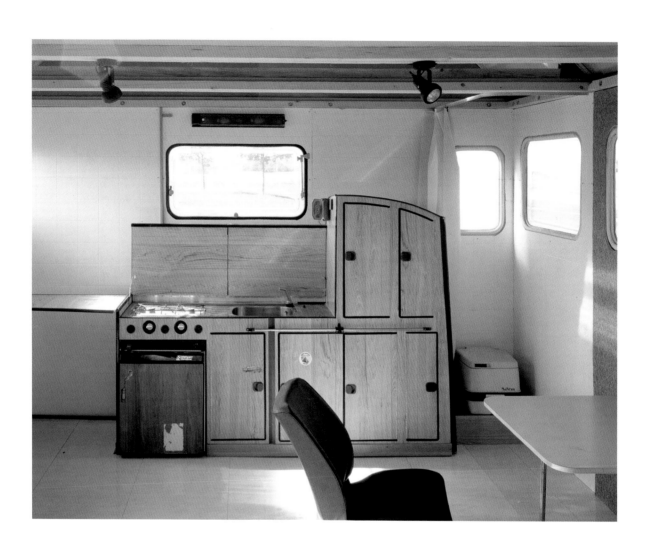

When we look at Sailstorfer's artistic practice, we can detect a similar propensity. In a pseudoscientific manner, but nevertheless with absolute commitment, he alters the base material, for example a mobile home, into another incarnation. Yet, he does not aim to hide the source: an alchemist in apprenticeship. Hence, these changes in form, structure, and character are just as absurd as the attempt to turn metal into gold. Sometimes, Sailstorfer's sculptural interventions can be mistaken for a hoax. With his abracadabra magic, he deliberately taunts our system of belief, assumptions, and expectations.

This idea is matched with his unstoppable and infectious inquisitiveness, a wish to explore the world. Sailstorfer is an inspired tinkerer. His childlike spirit of discovery can be understood as a trust in the power of play and imagination. One of the most successful of Sailstorfer's "Alice-in-Wonderland" projects is *D-IBRB* (2002). Here, Sailstorfer transforms a glider airplane into a tree house. With playful sensibility, he opts for unexpected situations by setting and creating his own parameters and guidelines. Why should not a plane land on the tree and turn into a tree house? This is only one example, in which Sailstorfer teases our preconditioned perception of our surroundings. Nevertheless, this metamorphosis works on several levels. "I see this piece," Sailstorfer explains, "working from the tension between the catastrophe and the games children play."[16]

Sailstorfer's inventions often maneuver between usefulness and futility, but always translate the sensual pleasure of their making. In his work, he seemingly reconciles two diverging principles of construction. The architectural paradigm 'form follows function" is paralleled with an 'everything goes' aesthetic.[17] With a remarkable do-it-yourself attitude, he forces the functionality of his transformed objects to the limit. Sailstorfer's work oscillates between following functional principles and simultaneously pushing them so far that in the end they become overturned and useless. "Familiar utility is turned with humour to uselessness," the critic Mark Gisbourne observes, "or, put another way, into an aesthetic usefulness: meaning and function are thus transposed to a second use value."[18] Through his work, Sailstorfer proves that there is not one solitary way of thinking about objects, and that a simple evaluation according to importance and significance does not always work. Sailstorfer's art questions the hierarchy of values and incessantly works

against categorical distinction. How, for example, to place a sofa fabricated by dismantling a house?

Indeed, Sailstorfer's artistic transpositions turn the house into an ironic object. They interrogate the instability of cultural signification. The house no longer conveys its traditional signified – its utility – but proposes an alternative set of implications as an aesthetic, but non-functional object. He physically and metaphorically destructs the function of the house, and in so doing, comments upon the unstable relationship between form and content. According to Sailstorfer, the function of an object and its material manifestations only exist in a constant flux. His sculptural transformations suggest fleeting moments, in which what appears to be permanent becomes transitory. In this vein, Sailstorfer's work can be read as an interpretation of his motto that nothing disappears, it just becomes something else.

Simone Subal

1 The exact measurements are 375 x 410 x 360 cm.
2 This makes an interesting allusion to Dan Graham's *Homes for America* project. In his text on suburban housing he equally stresses the disjunction of these houses with their environment: "Developments stand in an altered relationship to their environment…the houses needn't adapt to or attempt to withstand nature. There is no organic unity connecting the land site and the home. Both are without roots– separate parts in a larger, pre-determined synthetic order." Dan Graham, "Homes for America: Early 20th Century Possessable House to the Quasi-Discrete Cell of '66," *Arts Magazine* (December 1966 – January 1967): 22.
3 Ivanmaria Vele, "Boiler's Choice: Michael Sailstorfer," *Boiler Magazine, no.* 3 (November 2003): 11.
4 Besides the later discussed *Bad Dream House*, *Instant House* (1980), *Mobile Home* (1980) and *House of Cars* (1983) are worth mentioning.
5 Vito Acconci, "Homebodies," in *Vito Acconci: The City Inside Us*, ed. Peter Noever (Vienna: Museum für Angewandte Kunst, 1993), 90.
6 Vito Acconci, "Projections of Home," in *Vito Acconci*, ed. Amnon Barzell (Prato, Italy: Museo d'Arte Contemporanea Luigi Pecci, 1991), 126.
7 Mark Gisbourne, "Michael Sailstorfer: Email conversation 18 May, 2004," in *Manifesta 5: European Biennial of Contemporary Art* (San Sebastian, Spain: Centro Internacional de Cultura Contemporanea, 2004), 189.
8 These four small towns are all in close vicinity to Vilsbiburg, Sailstorfer's hometown.
9 Michael Sailstorfer in email conversation, October 13, 2004.
10 Jürgen Heinert was born in 1970, Syktywkar, Russia. He studied at the Akademie der Bildenden Künste in Munich (graduation in 2001). Heinert has received several grants such as a stipend for a three months stay at the Parsons School of Design, New York in 1998, and the DAAD scholarship for the Netherlands in 2001. He took part in a number of exhibitions mostly in Germany: *junger westen* at Kunsthalle Recklinghausen, 2001 *Kraft und Magie* at the Oberbayerische Kulturage, Altötting, 2001; *Wir, hier!* at lothringer 13/halle, Munich, 2003; *Go Johnny Go* at Kunsthalle Vienna, Austria.
11 Here, *3 Ster mit Ausblick* can be seen as an exception. But nevertheless, as discussed above, even though the viewer can see the different stages of the destruction, the individual shots or the frames are explicitly set apart from each other.
12 Gisbourne, 189.
13 Vele, 11.
14 Vele, 12.
15 Patrick Frey, *Ein ruheloses Universum: Zu den Gemeinsamen Arbeiten von Peter Fischli und David Weiss* (Basel: Kunsthalle Basel, 1985), 16. This analogy also came up in Belinda Grace Gardner's text on Sailstorfer's artistic practice, linking it to "architectonic alchemy." Belinda Grace Gardner, "Im Mercedes zu den Sternen: Michael Sailstorfer Macht die Skulptur Mobil," Kunstzeitung no. 98 (October 2004): 19.
16 Gisbourne, 189.
17 I adapted this thought from Patrick Frey's analysis of Fischli and Weiss' series *Stiller Nachmittag* (Quiet Afternoon), 1984–85, often referred to as the *Equilibres* (Balances) series.
18 Mark Gisbourne, "Michael Sailstorfer 2003," http://www.galeriemarkusrichter.de/eng/sailstorfer/sailstorfer_eng_texte.htm - up, March 17, 2005.
19 Gisbourne, "Michael Sailstorfer: Email conversation 18 May, 2004," 190.

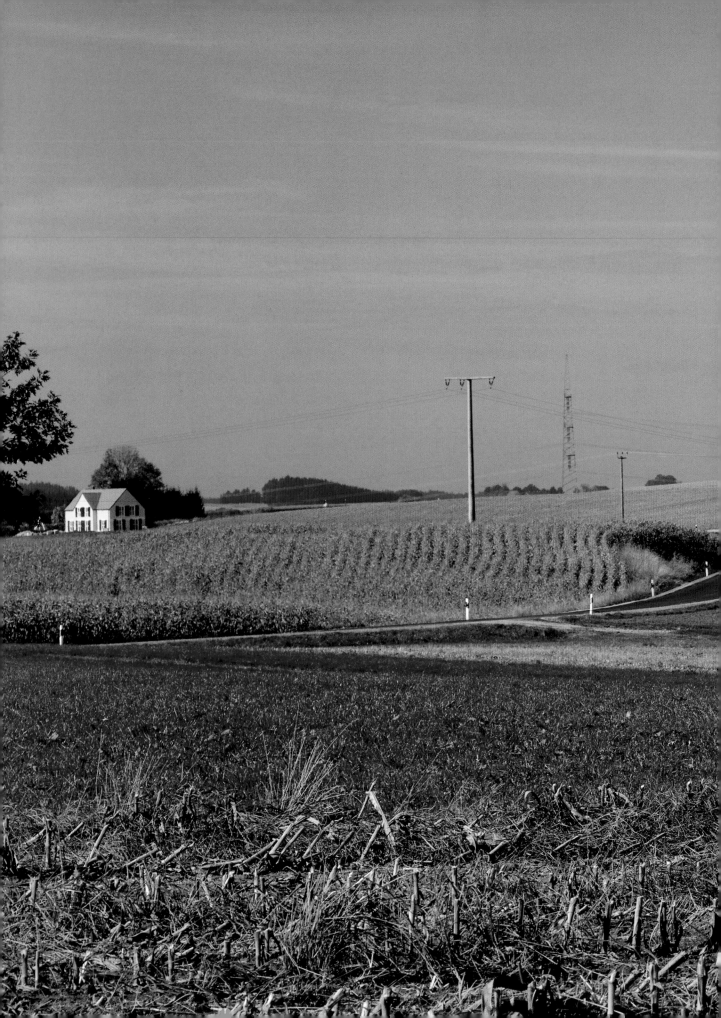

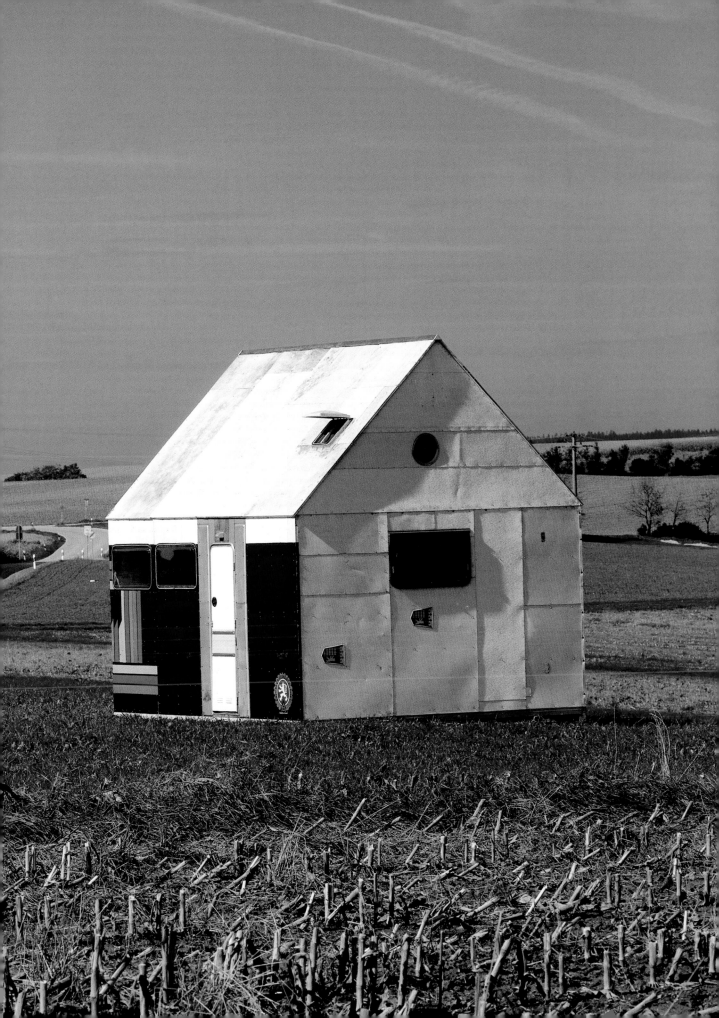

Kosmos und Hütte
Aporien der Heimat im Werk von Michael Sailstorfer

der mond ist

schwarz

und

innen

ein gedicht

Raoul Schrott (1993)

Im Werk von Michael Sailstorfer werden Sternschnuppen abgeschossen und Flugobjekte nachgebaut. Seine Arbeiten vermessen Mondkrater und lassen eine blaue Kugel samt leuchtendem Trabanten vor einem Scheinwerfer kreisen. Damit reichen sie immer wieder an das Gesamtgefüge des Weltgebäudes heran.

 Ihr Forschergeist folgt den astronomischen Wissensrevolutionen der frühen Neuzeit. Nach dem Wort des französischen Wissenschaftshistorikers Alexandre Koyré setzte sich mit der neuzeitlichen Astronomie metaphorisch ein „offenes Universum" an die Stelle des „geschlossenen Universums" des Mittelalters. Diese Offenheit, in der die Unendlichkeit des Kosmos durch kein theologisch geschlossenes Weltgebäude mehr begrenzt wird, stellte neben der physikalischen und mathematischen Frage der Umlaufbahnen zugleich auch die metaphysische Frage nach der Stellung des Menschen in der Welt. Schritt für Schritt öffnete sich das Universum des Sinns zur Unendlichkeit moderner Lebensentwürfe. Am Ende steht die Herausforderung, sich selbst in einer schlechthin unendlichen Welt einzurichten, in der auch jeder Platz beliebig ist. Das Weltgefühl im ‚offenen Universum', in dem das theologische Weltdach eingerissen wurde, findet in Georg Lukács' berühmtem Wort von der „transzendentalen Obdachlosigkeit" seinen Ausdruck. Wo sich das Universum nicht mehr um den Menschen wölbt, muss er sich ohne jeden Anhaltspunkt in der Leere entwerfen.

 Michael Sailstorfer konstruiert Modelle, die das geöffnete Universum greifbar nachvollziehen. Seine sperrig-allegorischen Objekte widmen sich den feinen, unwägbaren und unverfügbaren Stellen, die sich in ihm verbergen.

Aber Sailstorfer arbeitet auch spannungsreich am Gegenteil. Neben die Sehnsucht nach Unendlichkeit gesellt sich die nach Bestimmtheit und Geborgenheit. *Heimat* erscheint in Sailstorfers Werk als jene Kategorie der Geschlossenheit, die sich dem geöffneten Universum des Sinns gegenüberstellt. Kleine Refugien, Nester und Einnistungen bilden einen zweiten Schwerpunkt seines Werks.

In dieser Schwebe von Kosmos und Hütte exerzieren die Arbeiten von Michael Sailstorfer eine existenzielle Bewegung vor. Mal verträumt, mal verspielt, mal handwerklich analytisch und mal ganz bedrohlich variieren sie Erfahrungen von Unendlichkeit anhand des alltäglichen Problems, sich in ihr einzurichten. So stellen sie einige Grundfragen der Moderne an der Schnittstelle von säkularisiertem Wissen und alltäglicher Lebensgestaltung. Was bleibt, angesichts der Unendlichkeit des Kosmos, von jenem zufälligen Fleck, den wir Heimat nennen?

Abenteuer Unendlichkeit

Sailstorfers metaphorischer Ausflug zu den Sternen ist ein Wachsbild des Unbestimmten, ganz buchstäblich in der Arbeit *Cast of the surface of the dark side of the moon* (2005). Der Bodenabguss aus Fiberglas simuliert ein intimes und haptisches Wissen von einer Sphäre, der sich womöglich nicht einmal Astronauten je angenähert haben (verschwörungstheoretische Zweifel an den amerikanischen Mondmissionen sind im Umlauf). Mit der szientifischen Geste des Modellbauers spielt Sailstorfer damit eine Erfahrung durch, die die moderne Kosmologie nicht bietet: Die dunkle Seite des Mondes ist kein Ort, sondern eine seelische Landschaft, gleichwohl eine, die durch die moderne Astronomie deutlichen weltanschaulichen Aufwind erfahren hat. Denn sie ist ein unverfügbarer Punkt mitten in der Unendlichkeit, an die sich eben deswegen alle modernen Sehnsüchte des Ortes haften.

In seiner faserigen Materialität macht der schwarze Abguss jedoch auch deutlich, dass er bedeckt, was er zu entdecken hofft, dass er seinen Gegenstand nur allegorisch zu begreifen vermag, indem er ihn indirekt thematisiert. Die strohige Struktur und das schimmernde Schwarz tragen auf opake Weise dazu bei, die dunkle Seite des Mondes

eher als Rätsel zu bewahren, anstatt es zu lösen. In ihrem dekonstruktiven Verfahren erinnert Sailstorfers Mondabguss daher nicht zufällig an Robert Smithsons *Asphalt Rundown* (1969), das einen entlegenen Ort mit einer Ladung flüssigen Asphalts gerade dadurch markierte, dass es ihn verschüttete: Eine Kartographie des Unbestimmten, die den Raum als Sinnordnung und als eine Struktur zugleich erforschte und verbarg.

Die Farbsymbolik in Sailstorfers Monderkundung reicht noch über diesen enigmatischen Charakter hinaus. Dunkle Seite des Mondes – schwarze Säfte der Galle: *Melancholie* war der antike Name für jenes dem Saturn verbundene Temperament, das im Kern immer auch eine Sehnsucht nach Unbestimmtheit war. Melancholie ist, einschlägig in den Arbeiten von Michael Sailstorfer, das Bewusstsein von Unendlichkeit angesichts der Endlichkeit des eigenen Daseins, ein Ausflug, der von der eigenen heimatlichen Hütte sehnsüchtig in die Unendlichkeit des Kosmos führt.

Aber dieser Kosmos ist Gegenstand praktisch-technischer Interpretationen, keineswegs Zeichen allgemeinen Verstummens. Sailstorfer zieht es mit experimentellem Forschergeist in die Ferne, deren einfache Modelle ihre eigene Unangemessenheit auch exponieren. *Und sie bewegt sich doch!* (2002) ist ein Weltenmodell, das so clownesk wie einleuchtend ist. Die Erddrehung wird durch einen Automotor bewirkt und vollzieht sich vor dem Lichtschein eines Autoscheinwerfer. Samt Trabant dreht sich das Erdkarussell, gebaut aus Autoschrott und einer Straßenlaterne, zum Autolärm. Das trotzige *und sie bewegt sich doch* deutet, wo nicht mehr Galilei, sondern Sailstorfer diesen Satz anbringt, einerseits den Kraftakt an, den Kosmos zu ordnen und im

MODELL – UND SIE BEWEGT SICH DOCH!
2002

Modell zu erfassen. In diesem Sinn lässt der Titel aber andererseits auch die Betonung zu: *Und sie bewegt sich doch!*, immerhin *bewegt* sie sich! – eine Antwort, die sich ihrerseits auf das offene Universum zu beziehen scheint. Denn die keineswegs romantische Geste des laufenden Automotors, der die Welt am Laufen hält, enthält auch eine

Anspielung auf die rasende Sehnsucht, der Unendlichkeit der Welt durch Bewegung habhaft zu werden. Solange sich, so suggeriert diese automobile Deutung der Welt, der eigene Horizont fortwährend verschiebt, solange kann er der Unendlichkeit des Kosmos nicht allzu unangemessen sein: Metaphysik der Autobahn.

Mit der Freiheitssehnsucht eines Road Movie und dem Lärm der Motoren rekonstruiert Sailstorfer ein selbstgezimmertes Bild des Himmels, als wollte er es auf diese Weise mit der Unendlichkeit aufnehmen. Sein Modell greift in den Kosmos aus, um ihn einzufangen. Aber der Mercedes steht still und kommt vor dem Erdkarussell nicht vom Fleck. Die eigene Deutung der Welt wird selbst zum Karussell und die Endlosschleifen des Symbolischen drehen sich im Kreis. *Und sie bewegen sich doch nicht*, könnte man meinen, eine sinnlos-lärmende Maschine. Denn zuletzt ist die Unbeholfenheit des Weltmodells der entscheidendste Hinweis, den Sailstorfers Karussellobjekt gibt. Der metaphysische Deutungshorizont, der Gewissheit schaffen wollte, stößt an die Grenzen der Unbestimmtheit, bleibt an seinem eigenen Ort gefangen, so sehr er auch aufs Gaspedal der Welterschließung drücken mag.

Immerhin die Sehnsucht nach einer Welterfahrung, die den Himmel durchquert und *sich bewegt*, bleibt jedoch bestehen. Der Sternenhimmel hat mit der Sternschnuppe sein eigenes, romantisches Bild für diese intergalaktische Entdeckungsreise gefunden. Walter Benjamin sprach das mimetische Vermögen, Sterne und Himmelsbilder nachzuahmen, den alten Griechen zu und konnte es im zwanzigsten Jahrhundert nur noch bei Kindern erkennen. Tatsächlich ist jedem Träumer, der einmal einer Sternschnuppe nachgeschaut hat, etwas davon erhalten geblieben: Der Blick in die Sterne ist eine Projektion – die Sehnsucht, selbst in der Weite der Galaxien umherzuschwirren. Mit seiner *Sternschnuppe* (2002) spielt Sailstorfer dieses Experiment durch, empfindet Himmelsbewegungen nach, um den Kosmos zu erobern. Weniger als in *Und sie bewegt sich doch!* geht es dabei jedoch um die technisch-motorisierte Anstrengung, die Welt einzufangen. Vielmehr variiert sie die jugendliche Sehnsucht, erst einmal in sie auszuschwärmen. Auch hier lässt der Mercedes einen Hauch von Road Movie verspüren. Augenfälllig ist die überdimensionale Zwille, die die Straßenlaterne, die einmal Sternschnuppe werden soll, in

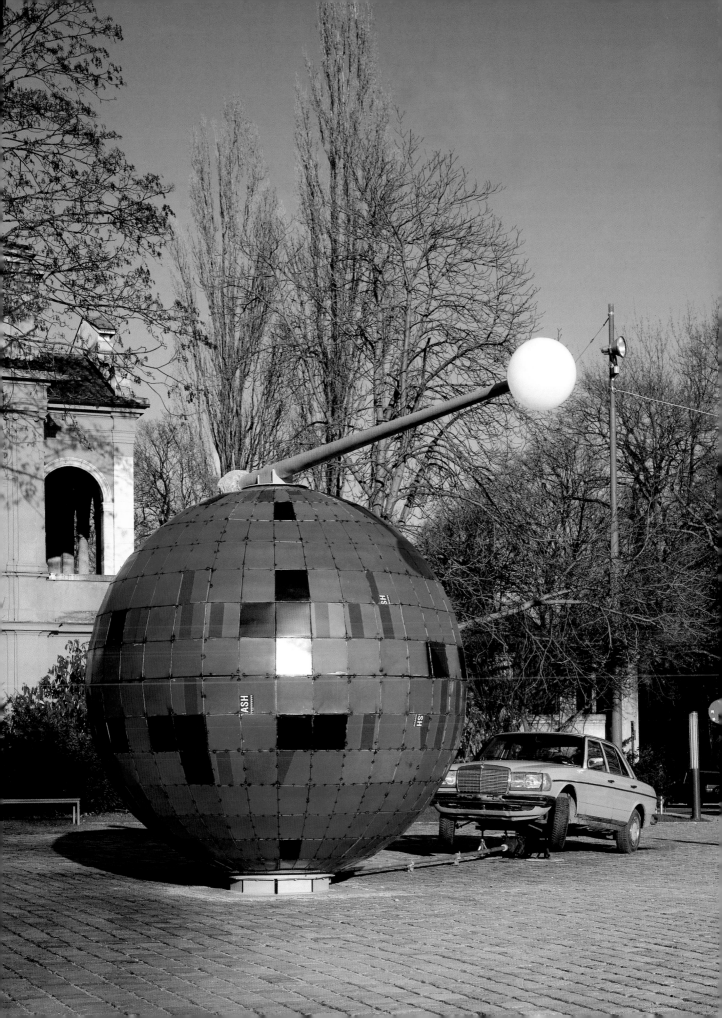

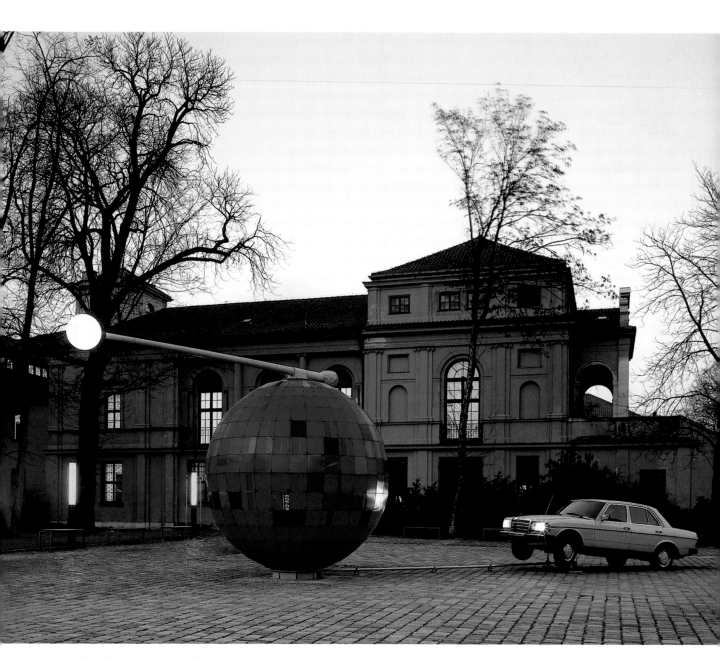

UND SIE BEWEGT SICH DOCH!
2002

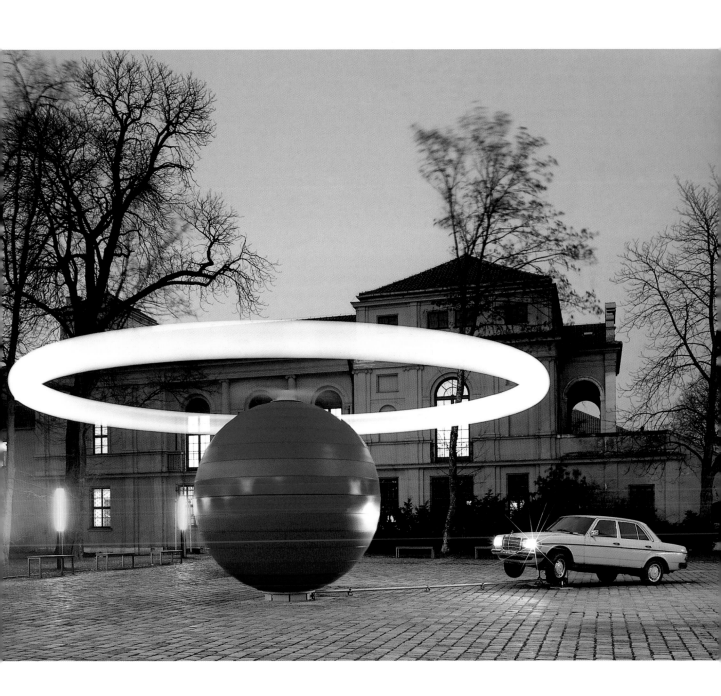

den Himmel schießt. Kindliche Entdeckerwünsche sind allemal angesprochen; Fernweh nach Unendlichkeit.

Behausungen im ‚offenen Universum'

„Denen allein wird die Erde gehören, die aus den Kräften des Kosmos leben." Nicht weniger als die Neuerfindung des eigenen Orts aus den Kräften der Unendlichkeit stand Walter Benjamin vor Augen, als er diese Zeilen schrieb. Mit seinen aporetischen Heimatbildern, die einen Ort in der Bewegung suchen, scheint Sailstorfer genau diese Bemühung nachzuvollziehen. Denn immer wieder sind Sailstorfers Hütten entweder aus Versatzstücken der Mobilität oder aber in translokale Orte des übergangs hinein gebaut.

Das Baumhaus *D-IBRB* (2002) setzt sich aus den Bestandteilen eines Segelflugzeugs zusammen. Mit den Chiffren des freien Flugs deutet es sowohl das Ausschwärmen an, als es, als Baumhaus, auch zu einer gewissen Sesshaftigkeit gefunden hat. Einigermaßen verschmitzt gibt es den Hinweis auf die große weite Welt, von der es sich gerade verabschiedet hat. Möglicherweise, so ließe sich assoziieren, hat das Segelflugzeug aus der Not des Absturzes die Tugend des Wohnens gemacht. Doch diese Not erhält im Kontext der Arbeit von Michael Sailstorfer besonderen Sinn. Sie ist, im Sinne Martin Heideggers, *existenziell* und somit nicht einfach durch bessere Flugtechniken zu überwinden.

Dem schwarzwälder Philosophen zufolge gehe allem Wohnen eine Spannung voraus. Wohnen finde, wie Heidegger in seinem Vortrag über *Bauen Wohnen Denken* (1954) erläuterte, im so genannten „Geviert" statt, inmitten einer Doppelachse aus Himmel und Erde, Sterblichkeit und Unsterblichkeit. Somit sei jeder Ort, den wir uns schaffen, der Herausforderung der Unendlichkeit mühsam abgerungen und diese in ihm noch spürbar. Indem er aber gerade diesem Widerstreit Ausdruck verleiht, gewinnt der Ort seine Kraft. Ein *eigentlicher* Ort im Sinne Heideggers, dem das Wissen um die existenziellen Schwierigkeiten des Wohnens innewohnt, ist ein Ort, der die Leere in sich selbst erfahrbar macht.

Sailstorfers *Heimatlied* (2001) schlägt dieselbe Melodie an. Wenn die Welt, im Sinne Heideggers, ein viel zu großer Zeltplatz ist, auf dem der erste Hering immer nur

einen beliebigen Platz findet, dann ist der wahre Ort eben ein Campingwagen, dem die Entschlossenheit angehört, sich im weiten Horizont niederzulassen. Deswegen hat Sailstorfers Wohnmobil die Räder abgestoßen und auf dem freien Feld seinen Ort gefunden. Nun ist es ganz Hütte, wenn auch gezeichnet von den Spuren der Ferne und der Autobahn. So werden Hütten in den Arbeiten von Michael Sailstorfer immer zur weiten Welt hin geöffnet. Der existenzielle Widerstreit hat in seinem Werk somit eine einfache Formel gefunden: *Wohnen mit Verkehrsanbindung* (2001).

Dabei gehört der Hütte immer auch die provinzielle Sehnsucht an, einen Ort zu finden, daheim zu sein. Nicht weniger als die Sehnsucht nach Ferne und Unendlichkeit ist die nach Heimat und Geschlossenheit im Werk Sailstorfers präsent. Die Hütte ist – anders als das Mietobjekt, die Zelle oder Wohnmaschine – die kleinste denkbare Form von Eigenheim. Privatheit, Gemütlichkeit und Geborgenheit sind ihre zentralen Attribute. *Heimatlieder* sind Sailstorfers Arbeiten zudem durch ihre regionalen Bezüge: der landschaftliche Kontext der gleichnamigen Installation, die landestypischen Buswartehäuschen in *Wohnen mit Verkehrsanbindung* und die Assoziationen der Gemütlichkeit (eines Holzfeuers in den eigenen vier Wänden, nach dem bayerischen Maß für Brennholz drei Ster genannt) in *3 Ster mit Ausblick* (2002, mit Jürgen Heinert). Aber diese besungene Heimat wird auch geopfert. In Anlehnung an Buster Keatons *The General* (1926), in dem Johnnie Gray, gespielt von Buster Keaton, den Materialwagen seiner Lokomotive gleich mitverheizt, verbrennt Sailstorfer die Holzhütte im eigenen Ofen.

Mitunter wurden Lokomotiven, so bei Marx oder Benjamin, als Sinnbilder für den historischen Fortschritt gebraucht. Und wo sich Geschichte global oder gar intergalaktisch ereignet, da wird sie zu jener „Furie des Verschwindens", als die Hegel sie beschrieben hat. In dem Augenblick, in dem sich der Kosmos kontinuierlich öffnet, da wird die Geschlossenheit provinzieller Heimatentwürfe aufgezehrt. Sailstorfer verheizt sie ostentativ im Holzofen.

Damit entwirft er einen geöffneten Raum, in den der Kosmos elementar eingeschrieben ist und in dem die Achse der Unendlichkeit an der Geborgenheit nagt. Heimat wird auf diese Weise global und ortlos. Wie Novalis zufolge alle Philosophie „eigentlich

Heimweh" sei, nämlich der „Trieb überall zu Hause zu sein", so zieht es auch Sailstorfer heimatverbunden in die Ferne – ein konstanter romantischer Unterstrom, der sein Werk kennzeichnet.

Abschottung und Spuk

Sailstorfer schert in den Kosmos aus und verknüpft die Bestimmtheit heimatlicher Orte mit dem Unbestimmten der Mobilität. Als abgeschottete Sphären hingegen generieren die Orte im Werk von Michael Sailstorfer einen eigentümlichen Spuk. Insbesondere die Fotoserie *Der Schein trügt* (2005) spricht diese Konstellation in ganzer Komplexität an. Die Fotos zeigen die Originalmasken der einzigen drei Gefangenen, denen es je gelang, aus Alcatraz zu fliehen (verfilmt wurde die spektakuläre Flucht von 1962 im Jahre 1979 mit Clint Eastwood). Aus Zementresten, Seife, Haaren und Kleidung haben sie Attrappen ihrer eigenen Körper gefertigt, die, um für die Flucht Zeit zu gewinnen, den Schein aufrechterhalten sollten, sie lägen weiterhin in ihren Betten.

Mindestens auf drei Ebenen thematisieren diese Attrappen das Einbrechen des Unbestimmten in die abgeschottete Welt, indem sie *erstens* den heroischen Freiheitswillen der flüchtigen Häftlinge dokumentieren. Mit ihnen wird (darin sind sie anderen Arbeiten Sailstorfers vergleichbar) das Ausbrechen aus einem ganz bestimmten Ort in die weite Welt erkennbar. *Zweitens* lassen sie mit dem Ausbrechen der Häftlinge jedoch auch ihr Einbrechen in eine scheinbar heile Welt erahnen – jene Welt, die sich ihrer durch Gefängnishaft entledigen wollte. In der abgeschotteten Welt jenseits von Alcatraz Welt eröffnet sich in diesem Sinn die Möglichkeit eines bedrohlichen Ereignisses, eines erneuten Verbrechens. Die Attrappen, die die flüchtigen Häftlinge in den Gefängnisbetten hinterlassen haben, symbolisieren *drittens* eine Anwesenheit, die es in den Zellen nicht mehr gibt und die als bestimmte Anwesenheit auch außerhalb der Gefängniswände nicht fassbar ist. Sie sind insofern eine Art umgekehrte Trophäe, die die Niederlage des geschlossenen und sich verschließenden Raumes zelebrieren.

Die heile Ordnung der Orte ist durch eine bedrohlich-unbestimmte Gegenwart gestört, ein Spuk. Und dass der Schein trügt, heißt nun ausdrücklich, dass Abschottung-

en trügerisch bleiben, weil sie die metaphysische Leere nicht schließen, die die unendliche Weite andeutet. Aus der Ungewissheit über das, was jenseits ist, spukt sie in jene sauber abgetrennten Sphären hinein, die ihre Sicherheit aus Geschlossenheit gewinnen.

Weniger komplex, aber nicht weniger eindringlich thematisiert *Hoher Besuch* (2005) dieselbe Konstellation. Denn auch dieser Besuch wirkt wie eine böse Überraschung, die in die ostwestfälische Provinz einbricht. Es bleibt auch hier schillernd, was da naht. Obgleich der Hubschrauber, den Sailstorfer auf dem Parkplatz des Museums MARTa in Herford platziert hat, ursprünglich ein russisches Modell ist (Typ MIL MI1), erinnert er zugleich an *Apocalypse Now* (1979) und die amerikanische Action-Serie *Airwolf*. So oder so: immerhin *Weltmacht* und *große weite Welt* lassen sich assoziieren. Ob politische Prominenz oder Mafia (im Bereich des großen Geldes verschwimmen die Differenzen), mit seinen verspiegelten Scheiben verheimlicht der Helikopter, wer tatsächlich zu Besuch kommt. Der *hohe Besuch* entspricht jedenfalls nicht der provinziellen Gemütlichkeit, die zu erwarten wäre und deutet die bedrohliche Anwesenheit von einem fremden, fernen, aber äußerst mobilen Gast an. Möglicherweise sind dessen Fremdheit und Mobilität selbst schon die entscheidenden Hinweise, so dass auch in *Hoher Besuch* die Bedrohungen der weiten Welt thematisch sind, die sie für die Gewissheiten der Heimat bedeuten.

Eine Form dieser Anwesenheit der weiten Welt in den gesicherten provinziellen Schutzzonen, ist ausdrücklich mit dem Reaktor-Unglück im sowjetischen Kernkraftwerk Tschernobyl angesprochen. Sailstorfer mobilisiert diesen welthistorischen Verweis mit subkulturellen Energien. *Reaktor* (2005) ist eine vibrierende PA, die auf die Gebäudeschwingung reagiert und die Rückkopplung zwischen Lautsprechern und Mikrophonen in eine körperlich erfahrbare Vibration steigert. Dabei ist die Arbeit einerseits eine formale Studie zu den (mit Nietzsche gesprochen) dionysischen Energien, die – durch den apollinischen Beton – formal im Zaume gehalten werden. Das technische Experiment an der Grenze von Sound und Vibration lässt die rohen Energien sinnlich fassbar werden, die im Inneren des Betons zu explodieren drohen. Ausdrücklich ist die Arbeit jedoch auch ein Porträt des Katastrophenreaktors von Tschernobyl, wie seine radioaktive Strahlung heute eben in einem Betonblock eingefangen ist. Aber ebenso wie der Betonblock um den Re-

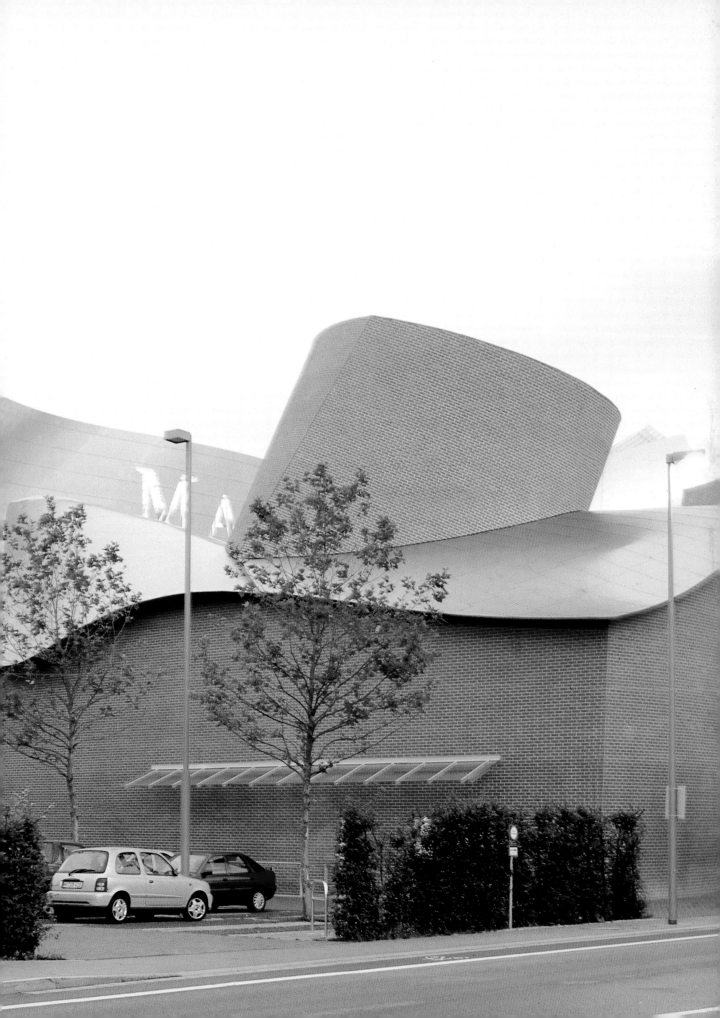

aktor von Tschernobyl bröckelt, beginnt auch der Betonblock um Sailstorfers Reaktor durch die immensen Vibrationen der in ihn eingebauten Soundinstallation Risse zu bekommen.

Trotz der Parallelen zum Katastrophenreaktor, Sailstorfers Reaktor ist durchaus formal motiviert, lotet eine ästhetische Spannung aus zwischen Ausdruck und Form. In diesem Sinn könnte man (mit Nietzsche) sagen: rohe Energie lässt sich apollinisch nicht letztgültig bändigen. Ein ästhetisches Glaubensbekenntnis, das den „Willen zur Kunst"

MODELL – REAKTOR
2005

(Beat Wyss) seit Schopenhauer nachhaltig charakterisiert. Um diese Spannung aber zurück zur Raummetaphorik von Kosmos und Hütte zu bringen, ließe sich übersetzen, keine Hütte schützt wirklich vor den metaphysischen Herausforderungen des Kosmos, vor den Bedrohungen, die *die Welt da draußen* für uns bereit hält. Etwas brodelt unterhalb der Ordnung der kleinen Welt, in der wir leben.

Wir Autobahnpiloten

So gesehen scheint das Heimatversprechen, das auch Sailstorfers Hütten geben, hoffnungslos uneinlösbar; sie schützen nicht und halten den Herausforderungen der Unendlichkeit nicht stand. Die einzige Möglichkeit, die Sailstorfer anzeigt, um auf die metaphorische Herausforderung des ‚offenen Universums' zu reagieren, ist Bewegung. Die Romantik der Autobahn spielt eine tragende Rolle in den Erzählungen von Heimat und Ferne, die Sailstorfer anschneidet. Als könnte Romantik ohne die Dynamik der Reise nicht einmal gedacht werden und Geborgenheit nur durch sie hindurch erreicht werden. *Dean & Marylou* (2003), das zärtlich unbeholfene Porträt der beiden Protagonisten aus Jack Kerouacs Roman *On the Road* (1957), die in ihrem Spiel aus Distanz und Nähe verliebt durch einen Busbalg verbunden sind, scheint diese Perspektive anzuzeigen. Weniger romantisch formuliert lässt sich zumindest sagen: Solange die eigene Sinn-

ordnung in Bewegung ist, treten ihre Grenzen nicht allzu schmerzlich hervor. Aber die Dynamik der Reise erscheint einerseits – so zumindest in *Und sie bewegt sich doch!* als ein rasender Stillstand, der zuletzt nur um sich selbst kreist. Andererseits erzeugt Bewegung Abrieb und lässt auch dadurch die eigene Vergänglichkeit aufschimmern. Abermals stoßen wir an die Grenzen der Sinngebäude, in denen wir uns einrichten: *Zeit ist*, so lehrt uns Sailstorfer, *keine Autobahn (2005)*.

Die gleichnamige Installation besteht aus einem Elektromotor und 400 Autoreifen, die durch diesen langsam an der Wand zerschlissen werden und sich langsam in einen Haufen Staub verwandeln. Langsam zerstäubt mit ihnen auch die Metaphysik der Bewegung. Nicht einmal die Perspektive der Mobilität lässt eine gesicherte Perspektive entstehen. Kein Zuhause, nirgends, nicht einmal mobil. Zumindest nicht für immer und nicht mit kosmisch-metaphysischer Gewissheit. Lediglich sehnen können wir uns mit Michael Sailstorfer danach. Ein kleiner, kurzer Trost für uns heimatvergessene Autobahnpiloten.

Johan Frederik Hartle

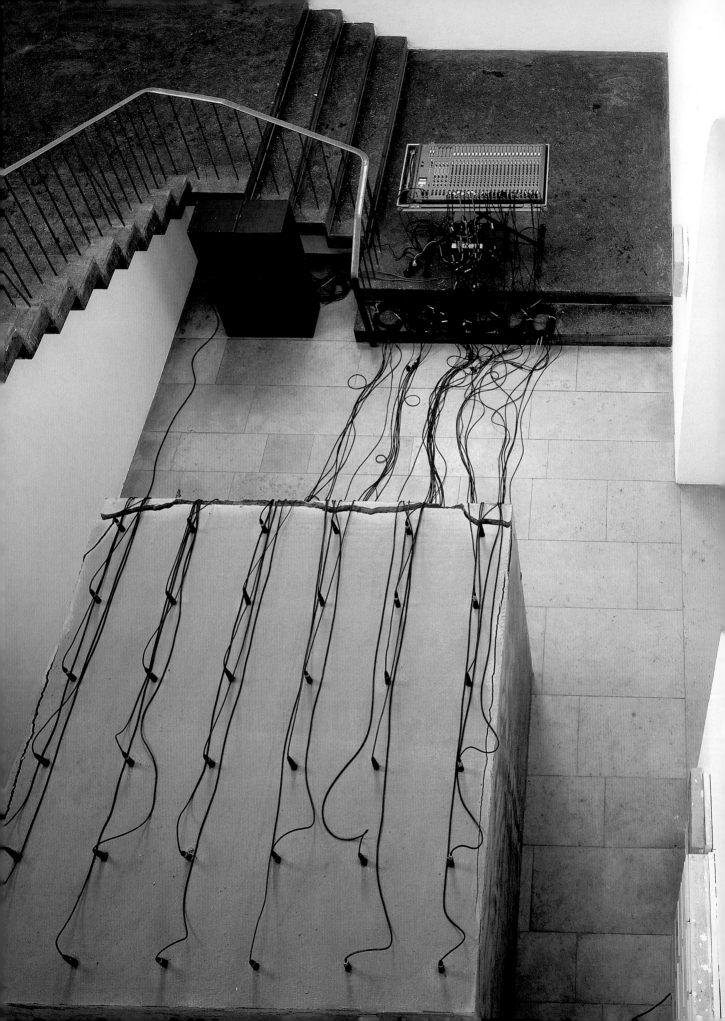

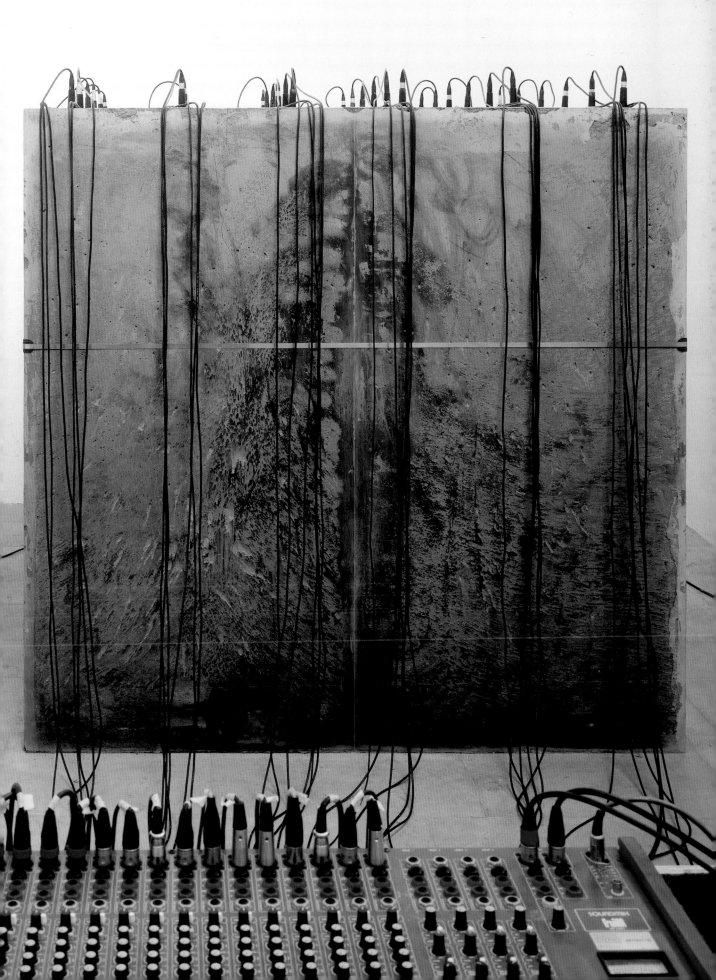

Cosmos and hut
Paradoxes of the home in Michael Sailstorfer's oeuvre

der mond ist

schwarz

und

innen

ein gedicht

Raoul Schrott (1993)

In Michael Sailstorfer's oeuvre, shooting stars get shot down and flying objects grounded. His pieces chart lunar craters and make a blue orb together with a shining satellite orbit a spotlight, and in so doing, they repeatedly approximate the overall structure of our global home.

The spirit of enquiry embodied by these works follows the revolutionary advances in our knowledge of astronomy in the early Modern age. In the words of Alexandre Koyré, the French historian of science, Modern astronomy metaphorically placed an "open universe" where Medieval times had located "closed universe". This openness, in which the infinity of the cosmos was no longer confined by a theologically closed world, set the metaphysical question of man's place in the world firmly alongside the physical and mathematical question of orbits. Step by step, the universe of meaning opened itself to the infinity of modern notions of personal life. In the end we are faced with the challenge of finding a home in a completely infinite world, in which all places are arbitrary. The global feeling in the "open universe", from which the theological roof has been torn off, finds expression in Georg Lukács' famous "transcendental homelessness". Where the universe is no longer a canopy over our heads, we must create our own lives, with no point of orientation in this emptiness.

Michael Sailstorfer builds models which tangibly trace the opened universe. His cumbersome, allegorical pieces address the pretty, imponderable and unavailable places lurking within himself.

Yet Sailstorfer also works excitingly at the opposite end of the spectrum. The long-

ing for infinity is joined by a desire for certainty and security. *Home* appears in Sailstorfer's work as that category of closure confronting the opened universe of meaning. Little havens, nests and niches form a second focal point of his work.

In this balance struck between cosmos and hut, Michael Sailstorfer's works play out a kind of existential move. Sometimes dreamy, sometimes playful, sometimes analytical and craftsman-like and sometimes decidedly threatening, they vary experiences of infinity with the everyday problem of finding our home in it. In this way, his work raises some of the fundamental issues of Modernity along the interface of secularized knowledge and the everyday life plans. Faced with the infinity of the cosmos, what remains of that accidental speck that we call home?

Adventure infinity

Sailstorfer's metaphorical trip to the stars is a wax model of the uncertain, quite literally in his *Cast of the surface of the dark side of the moon* (2005). The fiberglass cast of the

terrain fabricates an intimate and tactile knowledge of a world which even astronauts may not ever have got close to (doubts about the American lunar landings are floating about, stirred up by conspiracy theorists). With the quasi-scientific gesture of the model maker, with this work Sailstorfer offers us an experience not provided by modern cosmology: the dark side of the moon is not a place, but a landscape of the soul, although nonetheless one which has clearly been given an intellectual boost by modern astronomy. For this landscape is an unattainable point in the middle of infinity, that pivot where for that same reason all modern desires for place cling.

MODELL – CAST OF THE SURFACE OF THE DARK SIDE OF THE MOON
2005

However, the black cast also makes it clear in its fibrous materiality that it is covering over what it hopes to reveal, that it can grasp its purpose only allegorically by indirectly focusing on it as an issue. The straw-like structure and the shimmering black help,

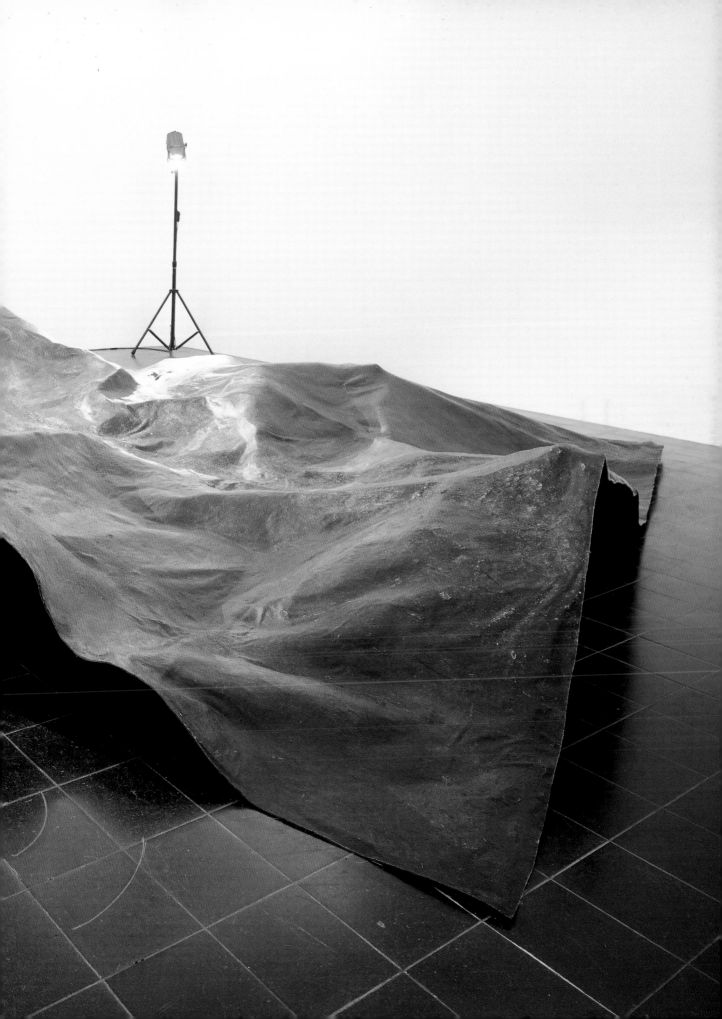

in an opaque way, to preserve the mystery of the dark side of the moon rather than shed light on it. Thus it is not purely by chance that in its deconstructive technique, Sailstorfer's cast of the moon resembles Robert Smithson's *Asphalt Rundown* (1969), which spotlighted a remote place with a truckload of liquid asphalt and thus masked it. This was a cartography of the undefined, which at once both explored and concealed space as semantic order and as structure.

The symbolism of color in Sailstorfer's lunar investigation goes beyond even this enigmatic character. Dark side of the moon – black bile juices: prior to the Enlightenment *melancholy* was the word used for the temperament, associated with Saturn, which really always also meant a yearning for indefiniteness. As is poignantly revealed by Michael Sailstorfer's work, melancholy is the awareness of infinity in the face of the finite nature of our own existence. It is a journey from the huts that we call home, and which longingly reaches into the infinity of the cosmos.

But this cosmos is an object open to practical and technical interpretations and certainly not a symbol of universal silence. With the zest of an experimental researcher, Sailstorfer reaches far-away places, whose simple models also expose their own inadequacy. *Und sie bewegt sich doch!* (And yet it does move!, 2002) is a model of the world which is as zany as it is clear. The engine of a car connected to the model powers the earth in its spin, illuminated by the car's headlamps. The model, made from parts of old cars and a street lamp and complete with satellite, spins to the sound of traffic. Since it is not Galileo but Sailstorfer who has created this defiant model, on the one hand *Und sie bewegt sich doch!* hints at the mammoth task of organizing the cosmos and representing it. On the other hand, it is in this sense that the title emphasizes the fact that *And yet it does move*, it is *moving* after all! – an answer which for its part appears to relate to the open universe. Because the car engine keeping the earth spinning has absolutely nothing romantic about it and instead also alludes to our desperate longing to use movement to somehow gain control of the world's infinity. This automobile interpretation of the world suggests that as long as our own horizon continues to move, it cannot be altogether inappropriate to the infinity of the cosmos: Expressway metaphysics.

With a yearning for freedom similar to that found in a road movie and the noise of the engine, Sailstorfer personally nails together a picture of the skies, as though he wanted to use it to take on infinity. His model reaches out into the cosmos in order to capture it. But the stationary Mercedes makes no headway against the spinning earth. This personal interpretation of the world itself becomes a merry-go-round and the infinite loops of symbolism spin round in a circle. *And they are not moving after all*, you could say, a meaningless, rackety machine. Last but not least, the model's clumsiness is the most crucial evidence Sailstorfer gives. The metaphysical horizon of interpretation, which it was hoped would encourage certainty, comes up against the limits of indeterminacy, stays captured at its own place, however much it may press the accelerator of world development to the floor.

After all, the longing for an experience in the ways of the world that traverses the skies and actually *moves* has not been satisfied. The firmament has found its own romantic image for this intergalactic journey of discovery in the guise of the shooting star. Walter Benjamin claimed that the ancient Greeks had the ability to imitate the stars and constellations, and noticed that in the 20th century it was displayed only by children. In fact, any dreamer who has ever seen a shooting star has been touched by it: Star gazing is a projection of our yearning to buzz about in the depths of the galaxies. Sailstorfer runs through this scenario in *Sternschnuppe* (Shooting star, 2002), traces celestial movements so that he can capture the cosmos. Although to a lesser degree than *Und sie bewegt sich doch!, Sternschnuppe* also employs motorized parts to capture the world. In fact it varies the youthful longing to first of all go off and explore it. Here, again, the Mercedes gives a hint of the road movie. The oversized slingshot shooting the street lamp (soon thus to become a shooting star) into the sky certainly stands out. It definitely appeals to childish dreams of discovery: wanderlust for infinity.

Housing in the 'open universe'

"The earth will belong solely to those who live by the forces of the universe". What was foremost in Walter Benjamin's mind when he wrote these words was the reinvention of his

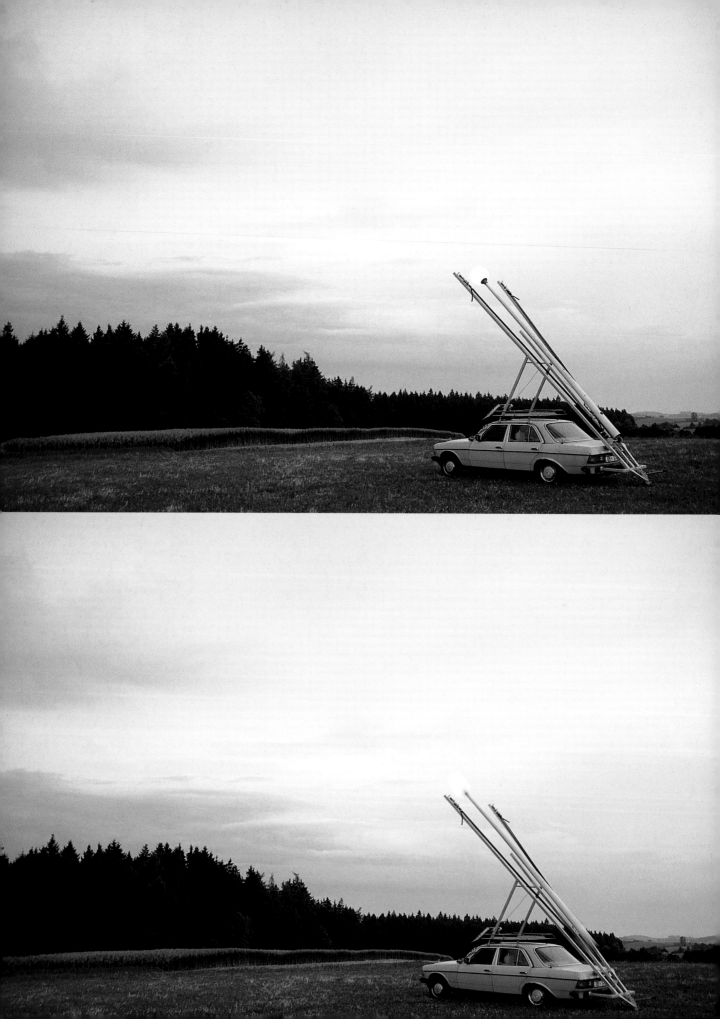

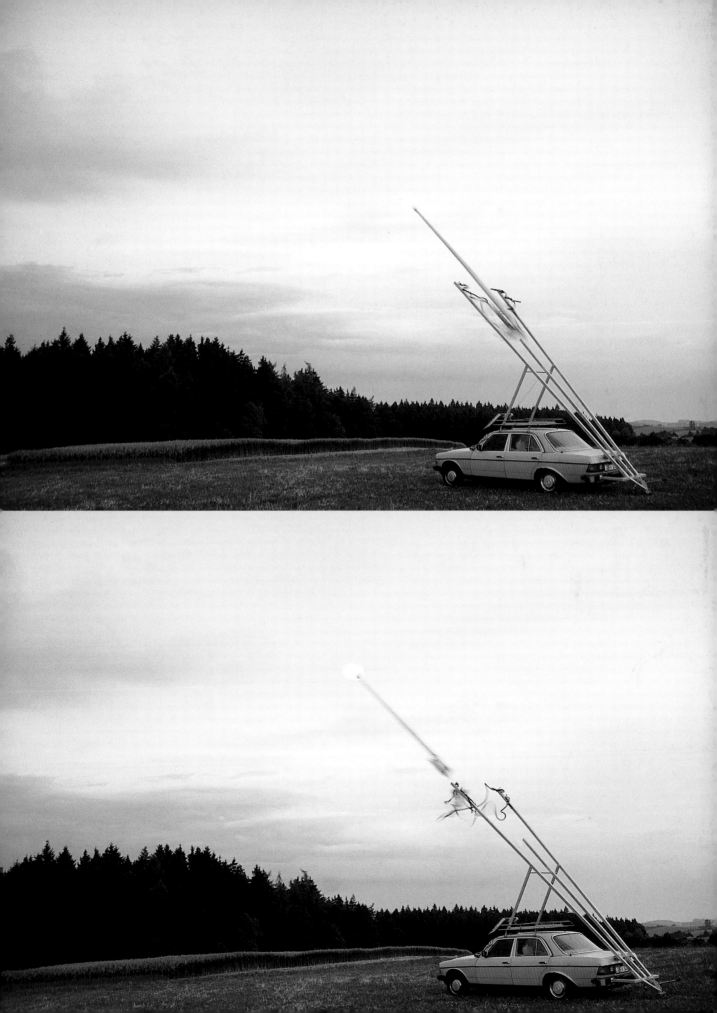

own place in the world by means of the forces of infinity, no less. It is precisely this endeavor that Sailstorfer appears to reproduce with his paradoxical images of home, which search for a place within flux. Because Sailstorfer's huts are repeatedly made either of mismatched pieces of mobile objects or built inside the trans-local base of transition. The tree house *D-IBRB* (2002) is constructed from parts of a glider. Since it was once capable of free flight it implies both the ability to go out and explore, and, as a tree house, that it has found a measure of sedentation. Somewhat mischievously, it conjures up an image of the big wide world it has just said farewell to. In turn, we could say that the glider has possibly made the best of its nadir, i.e., its crash, by this illustration of habitation. Indeed, this low point is particularly significant in the context of Michael Sailstorfer's work. It is, for Martin Heidegger, *existential* and therefore cannot be overcome simply with better aerial technology.

According to the philosopher, originally from the Black Forest, living is always preceded by a type of tension. As Heidegger commented in his lecture *Bauen Wohnen Denken* (Build Live Think, 1954), living takes place in the so-called "quartered square" in the middle of a dual axis of earth and sky, of mortality and immortality. Consequently, the challenge of infinity is laboriously overcome in every place we create for ourselves, and yet it is still present. However, the place obtains its power precisely by giving expression to this conflict. An *authentic* place as Heidegger sees it, with an intrinsic knowledge of the existential difficulties of living, is a place which allows us to experience the innate emptiness.

Sailstorfer's *Heimatlied* (Homeland song, 2001) strikes up the same tune. In Heidegger's view, when the world is far too large a camping site, where the first tent peg always struggles to find room, then the true place is just a caravan, which has the determination to go and settle on the far horizon. It is for this reason that Sailstorfer's motor home has jettisoned its wheels and found its place in open country. Now it is entirely a hut, albeit one seen from distant roads and from the motorway. In the works of Michael Sailstorfer, huts are always opened up in this way to the wide world. Thus the existential conflict has found a simple expression in his work: *Wohnen mit Verkehrsanbindung* (Living with transport connection, 2001).

Also associated with the hut is always our provincial yearning to find a place where we can be at home. The longing for home and closeness is just as present in Sailstorfer's work as is that for distant adventure and infinity. The hut is, in contrast to rented space, compartment or other living arrangement, the smallest form of home conceivable. Privacy, comfort and security are its central attributes. Sailstorfer's works are also *Heimatlieder* (Homeland songs) because of their regional inferences: the scenic context of the installation bearing the same name, the traditional bus shelter in *Wohnen mit Verkehrsanbindung* and the connotations of coziness (a wood fire in your own four walls, named 'three steres' after the Bavarian measure of firewood) in *3 Ster mit Ausblick* (3 Steres with a view, 2002, with Jürgen Heinert). But this celebrated home also becomes a sacrifice. Drawing on Buster Keaton's *The General* (1926), in which Johnnie Gray, played by Buster Keaton, burns the fuel cart of his locomotive, in a similar way Sailstorfer burns down the wooden hut using its own oven.

Sometimes locomotives have been used as symbols of historical progress, for example by Marx or Benjamin. And where history unfolds, whether global or intergalactic, it becomes that "Harpy of Disappearance", as Hegel described it. It is in the moment in which the cosmos continuously opens itself that the closeness of provincial feelings of home sputters and dies. Sailstorfer burns this closeness in spectacular fashion in a wood oven.

In this way he designs an opened space on to which the cosmos is fundamentally inscribed and in which the axis of infinity gnaws away at our security. Home is in this sense global and only abstract. Since, according to Novalis, all philosophy is "really homesickness", and in particular the "drive to be at home everywhere", it therefore also pulls Sailstorfer to far away places, while retaining an affinity with the home – a steady, romantic undercurrent which defines his work.

Sealed places and ghosts

Sailstorfer swerves out into the cosmos and connects the certainty of the places we call home to the uncertainty of mobility. On the other hand, places as sealed-off spheres in

the work of Michael Sailstorfer generate a peculiar ghost. The series of photos *Der Schein trügt* (Appearances deceive, 2005) in particular addresses this point in all its complexity. The photos show the original masks worn by the only ever three prisoners to escape from Alcatraz, (the spectacular escape of 1962 was made into a film in 1979 starring Clint Eastwood). To buy time for their escape, they made dummies of themselves from bits of cement, soap, hair and clothes to make it look as though they were still lying in their beds.

These dummies represent uncertainty's infiltration of the insular world on at least three levels, *firstly*, by documenting the heroic will and desire for freedom among the fleeing prisoners. They illustrate a break-out from a definitive place into the wide world, and it is in this way that they are comparable with other works from Sailstorfer. *Secondly*, by conjuring up images of the prisoners' escape, the dummies also let us picture their break-in to a seemingly safe world – that world which intended to do away with theirs through imprisonment. In the sealed-off world beyond that of Alcatraz, the possibility of a threatening event, a renewed crime in this sense becomes real. The dummies the short-term prisoners have left behind in their beds symbolize *thirdly* a presence, which is no longer in the cells and which, as a definitive presence, is also incomprehensible outside the prison walls. In this respect they are a type of inverted trophy celebrating the defeat of the closed and self-sealing space.

The safe order of places is disturbed by a threatening and uncertain present, a ghost. And that appearances deceive, expressly means that insulations remain deceitful, because they do not fill the metaphysical gaps hinted at by the infinite expanse. Out of the uncertainly as to what is out there, this expanse haunts those wholly separate spheres which gain their security from their closeness.

Hoher Besuch (Official visit, 2005) illustrates the same constellation in a less complex, but not less insistent manner. Because this visit also has the effect of an unpleasant surprise, which is branching out into eastern Westphalia. It keeps on dazzling here, whatever is approaching there. Although the helicopter that Sailstorfer has pos-

itioned in the parking lot of the MARTa Museum in Herford was originally a Russian model (MIL MI1), at the same time it reminds us of *Apocalypse Now* (1979) and the American action series *Airwolf*. Either way, *world power* and *big wide world* are associated with each other anyway. Whether someone of political prominence or a member of the Mafia (where large amounts of money are concerned distinctions tend to blur), the helicopter hides the true identity of the visitor behind its shiny panels. In any event, *Hoher Besuch* does not provide the provincial coziness that you would expect and implies the threatening presence of a foreign, distant, but extremely mobile guest. Their foreignness and mobility are perhaps themselves the deciding references, so that in *Hoher Besuch* as well, the threats the wide world has for home certainties are the theme.

One form of this presence of the wide world in protected provincial areas is explicitly exemplified by the reactor meltdown at the Soviet nuclear power plant in Chernobyl. Sailstorfer mobilizes this historic event of global importance using sub-cultural energies. *Reaktor* (Reactor, 2005) is a vibrating polyamide which reacts to the vibrations of the building and increases the reaction/feedback between loud speakers and microphones allowing us to physically experience the vibration. Hence, on the one hand, the work is a formal study of Dionysian energies (to borrow from Nietzsche), which – through the Apollonian concrete – are formally kept under control. This technical experiment on the boundaries of sound und vibration allows us to actively comprehend the raw energies threatening to explode within the concrete. However, this piece is also an explicit portrait of the remains of the reactor at Chernobyl, as today its radiation is contained by a concrete block. Yet just as the concrete block around the Chernobyl reactor is disintegrating, the concrete block of Sailstorfer's reactor is also beginning to show cracks, because of the immense vibrations produced by the in-built sound system.

Despite the parallels to the Chernobyl reactor, Sailstorfer's reactor is thoroughly technically motivated, it plumbs the depths of an aesthetic tension between expression and form. In this sense you could say (again drawing on Nietzsche): raw energy cannot be subdued using Apollonian means in the final instance. An aesthetic profession of faith,

which has effectively characterized the "Willen zur Kunst" (Beat Wyss) since Schopen-hauer. In order to relate this tension back to the spatial imagery of the cosmos and hut, it could be interpreted that no hut really protects us from the metaphysical challenges of the cosmos or the threats that *the world out there* holds for us. Something is brewing under the ordered surface of the small world we live in.

We freeway pilots

Seen in this light, the promise of home that Sailstorfer's huts also give seems hopeless-ly irredeemable; they do not protect us and do not withstand the challenges of infinity. The only possible way in which Sailstorfer shows we can respond to the metaphorical

challenge of the "open universe" is through move-ment. The romanticism of the freeway has a central role in the stories of home and far off places, which Sailstorfer touches on. It is as though we could not even think about romance without the dynamicity of travel and as though we could only create a sense of security through this dynamicity. This perspective appears to be displayed in *Dean & Marylou* (2003), the charmingly clumsy portrait of the two protagonists of Jack Kerouac's Roman *On the Road* (1957), who in the playful interaction of distance and closeness are

MODELL – DEAN & MARYLOU
2003

lovingly connected by a bellows. Less romantically put, we can at least say: As long as our own sensory perception is in motion, its borders do not make themselves felt too painfully. But on the one hand the dynamics of travel appears, in *Und sie bewegt sich doch!* at least, as a frantic standstill which ends up just going round in circles. On the other hand, movement results in wear and it therefore highlights its own transience. Again we stumble against the walls of the structures of perception in which we make ourselves comfortable. As Sailstorfer teaches us, *Zeit ist keine Autobahn* (Time is not a motorway, 2005).

The installation of the same name consists of an electric motor and 400 car tires, which are slowly battered to pieces against a wall by the motor and slowly turn into a pile of dust. Slowly the metaphysics of movement turn into dust with them. Not even with the perspective of mobility can we create a perspective of security. No home, nowhere, not even mobile. At least not forever and not with cosmic-metaphysical certainty. All we can do is long for it with Michael Sailstorfer. A small, brief solace for us freeway pilots forgotten by our home.

Johan Frederik Hartle

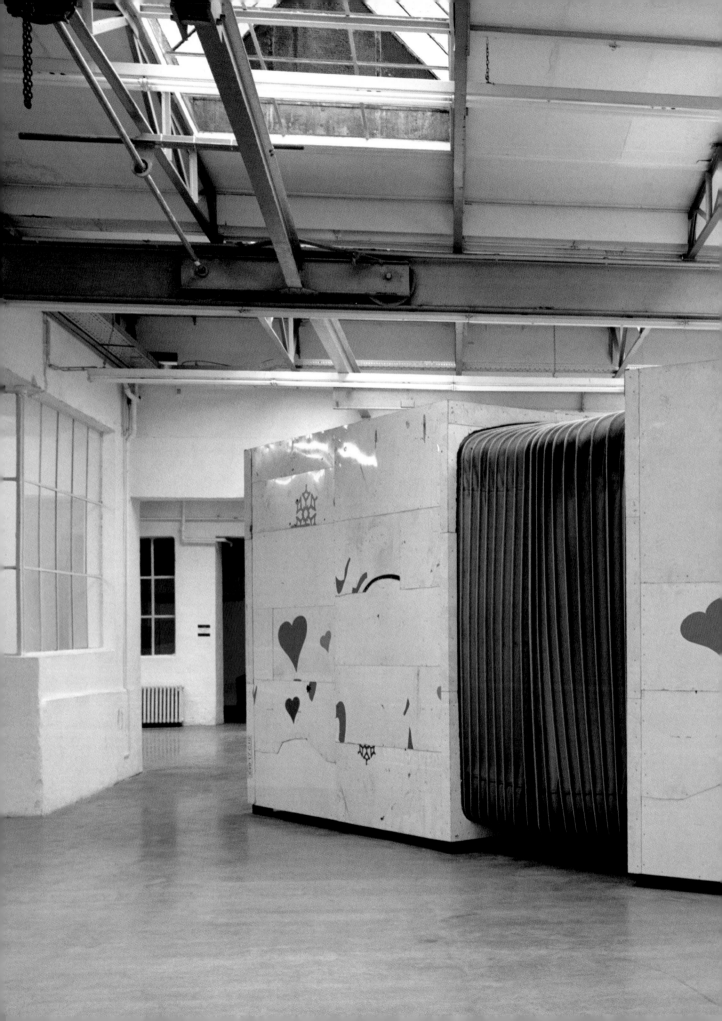

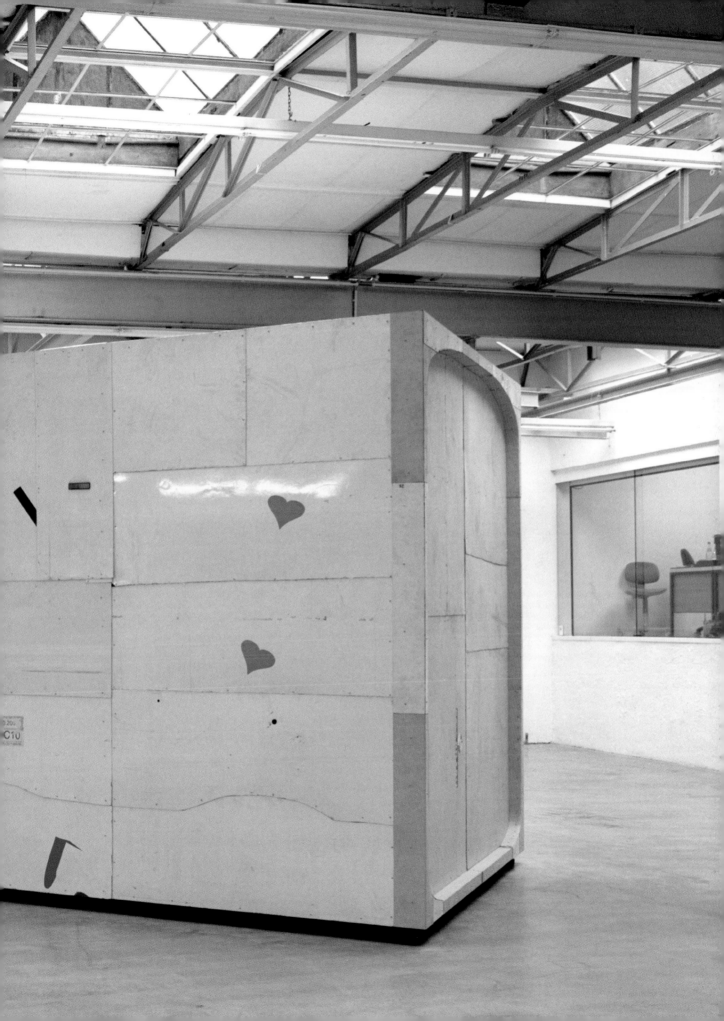

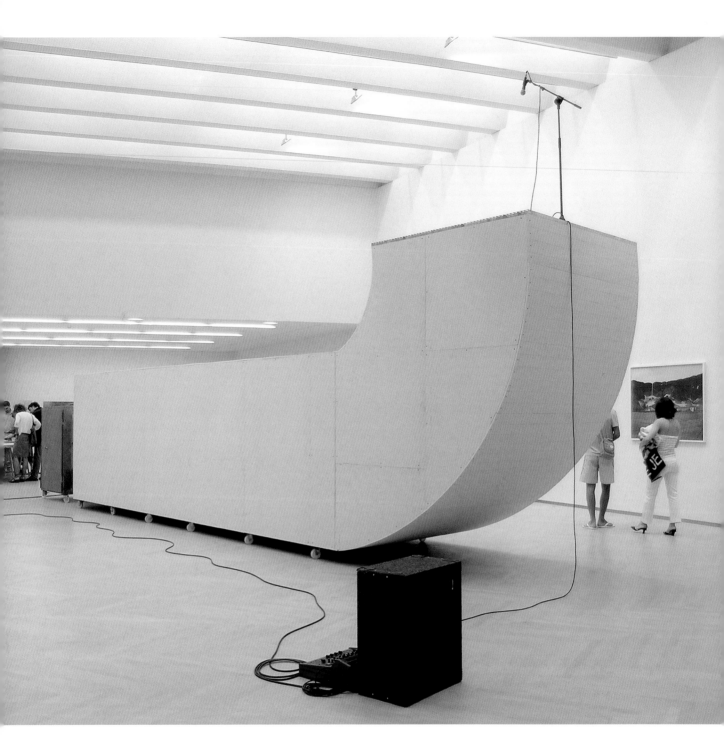

VERSUCHSAUFBAU MARILYN
2004

Massimiliano Gioni im Gespräch mit Michael Sailstorfer
Oktober 2005

Wer bist Du?

Michael Sailstorfer.

Was machst Du?

Zunächst bin ich Beobachter. Bezugspunkt meiner Arbeiten ist die Welt. Genauer, wie man sich in dieser Welt zurechtfindet. Vielleicht kann man das, was ich tue mit dem Schreiben eines Songs vergleichen. Man nimmt, was einen umgibt und beschäftigt, und macht einen Song daraus, manchmal wird man von Heimatlosigkeit getrieben, manchmal von Fernweh. Klingt ziemlich romantisch, aber das treibt mich an, Dinge zu tun.

Was interessiert Dich?

Kunst. Minimal Art, Konzeptkunst, Fluxus, Landart, Architektur. Im Moment bin ich besonders an der Kombination von formalen Strukturen mit erzählerischen Elementen interessiert.

Wo machst Du Deine Arbeiten?

Nahezu alle meine Arbeiten sind ortsbezogen. Bevor ich eine Skulptur an einem bestimmten Ausstellungsort platziere oder eine Arbeit für einen Ort baue, setze ich mich intensiv mit diesem Ort und der Umgebung auseinander. Dabei spielt es keine Rolle, ob es sich um eine Galerie, einen Museumsraum oder irgendeinen Fleck in der Landschaft handelt. Man muss immer entscheiden, welche Größe, Form, Materialität, Farbe ein jeder Standort bedingt. Die Mindestanforderungen, damit aus dem Song ein Hit wird.

Du bist also an Erfolg interessiert?

Es wäre eine Lüge, das zu verneinen. Tatsächlich ist es aber vor allem die Herausforderung, die mich antreibt; es geht nicht nur um Anerkennung. Ich mache diesen Job noch nicht lange, aber ich glaube, ich mag es, meine Handschrift zu verändern. Wenn ich merke, dass ich etwas einigermaßen gut kann, habe ich das Bedürfnis, etwas Neues zu versuchen. So fühle ich mich wohler. Es langweilt mich, immer die gleichen Dinge zu tun.

Diese Einstellung möchte ich mir auch in Zukunft erhalten. Arbeiten für eine kontinuierlich wachsende und sich verändernde Welt.

An was arbeitest Du im Moment?

Gerade baue ich in Yokohama meine Arbeit *Zeit ist keine Autobahn* für die Yokohama Triennale auf. Das Lagerhaus in dem die Triennale stattfindet, befindet sich auf dem Pier vor Yokohama und war ursprünglich ein Lager für Lastwagenreifen. Ich habe einige der Reifen im Gebäude gelassen und eine Maschine gebaut, die die Reifen verschleißt. Ein Elektromotor dreht beständig einen Reifen, der gegen die Wand gepresst wird. Der Reifen nutzt sich langsam ab und muss nach einiger Zeit ausgewechselt werden. Auf dem Boden sammelt sich der Gummistaub des Reifens. In der Ganzen Halle riecht es nach Gummi. Den gleichen Geruch nimmt man wahr, wenn man auf dem Weg zur Ausstellung an den anderen Lagerhäusern auf dem Pier vorbeikommt.

Was ist für Dich ein Objekt? Und was bedeuten Kraft oder Energie für Dich?

Wenn Rio Reiser *König von Deutschland* singt, dann ist das Energie. Verglichen mit vielen Kunstwerken, die ich gesehen habe, ist das viel Energie. Verglichen mit einem Taifun ist das nichts. Eine Skulptur ist ein Objekt. Etwas unbedingt machen zu wollen, ist auch ein Objekt. Es ist gut, dass Du diese beiden Fragen gestellt hast. Die eigentliche Frage für mich lautet, wie kann ich ein Objekt mit Energie aufladen.

Was ist für Dich ein Unfall?

Wenn zwei Dinge mit Wucht aufeinander treffen.

Was ist für Dich Lärm?

Lärm bedeutet, dass etwas in Aktion ist, sich bewegt, atmet. Lärm ermöglicht es, Zeit wahrzunehmen. Etwas, das Lärm macht, lebt. Ich denke, deshalb habe ich bei einigen Arbeiten Skulptur mit Sound kombiniert – um ihnen eine Timeline zu geben. Und um den ganzen Raum zu füllen. Sound ist Skulptur. Er ist dreidimensional. Was ich an Lärm

auch mag, ist die Tatsache, dass man ihn nicht so leicht ignorieren kann. Es ist einfach, ein Bild an der Wand zu ignorieren, aber wenn man Lärm ausgesetzt ist, dann muss man sich damit auseinandersetzen.

Was ist dann Stille?
　　Tod.

ZEIT IST KEINE AUTOBAHN – YOKOHAMA
2005

Massimiliano Gioni in conversation with Michael Sailstorfer
October 2005

Who are you?

 Michael Sailstorfer

What do you do?

 At first I am an observer. Benchmark for what I am doing is the world. More specifically how man arranges himself in the world. Maybe you can compare what I am doing to writing a song. You take what surrounds you and bothers you and put it in a song, sometimes driven by homelessness, sometimes by itchy feet. Sounds super romantic but that's what makes me do things.

What are you interested in?

 Art. Minimal, Conceptual, Fluxus, Landart, Architecture. At the moment I am very interested in the combination of very formal structures with narrative elements.

Where do you make your work?

 Almost all the works are site specific. Before I place a sculpture in a certain venue or before I start building a piece for a location I deal quite intensely with the place and the surrounding. Does not matter if it is for a gallery or a museum space or somewhere in the countryside. You always have to decide what size, shape, material, colour is needed for each site. Basic requirement for the song to become a hit.

So are you interested in success?

 It would be a lie if I said no. But in fact it is rather the challenge that drives me; it is not just about gaining recognition. I am not doing this job since a long time but I think I like to change my style. When I realize that I can do something quite well I have to make a turn and try something new. I feel more comfortable this way, instead of getting bored by doing the same things over and over again. That's something important for me to maintain in the future. Working for a constantly growing, moving world.

What are you working on at the moment?

Now I am in Yokohama installing my work *Zeit ist keine Autobahn* (Time is not a motorway) for the Yokohama triennale. The warehouse where the triennale takes place is on the pier of Yokohama and was a storage place for truck tires. I left some of the tires in the building and built a machine to consume the tires. An electric motor turns constantly a tire, which is pressed against the concrete wall. The tire is slowly worn out and has to be changed after some time. The floor gets covered with the rubber dust. You can smell the rubber. You can find the same aroma on the way to the exhibition when you pass by the other warehouses on the pier.

What's an object for you? And what is power or energy for you?

Rio Reiser singing *König von Deutschland* is power. Compared to a lot of artworks I have seen that's a lot of power. Compared to a typhoon that's nothing. A sculpture is an object. An attempt, if you want to do something, that's an object, too. I am happy you pose these two questions together. The question for me is how to equip an object with energy.

So what's an accident for you?

If two things hit really hard.

What's noise for you?

Noise means that something is in action, moving, breathing. Noise makes you experience time. Something making noise is alive. I think this is why I decided to combine some sculptures with sounds – to give them a timeline. And to fill the whole space. Sound actually is a sculpture. It is 3 dimensional. What I also like about noise is that you can't ignore it that easily. It is easy to ignore a painting on a wall. But when you are exposed to sound, then you have to deal with it.

So what's silence?

Death.

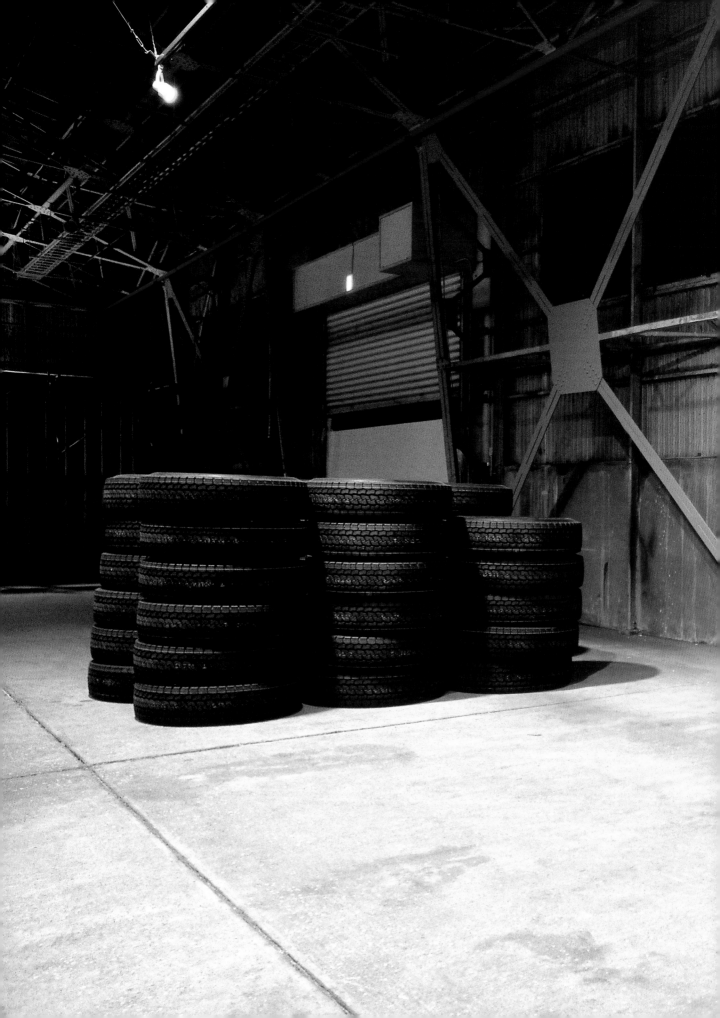

ZEIT IST KEINE AUTOBAHN – YOKOHAMA
2005

Verzeichnis der abgebildeten Werke
Index of illustrations

Umschlag cover
Zeit ist keine Autobahn 2005
Installationsansicht Installation view:
Rote Zelle, München
Autoreifen, Eisen, Elektromotor, Strom
Car tyres, iron, electric motor, electricity
Größe variabel
Size variable
Photo: Michael Sailstorfer
Privatsammlung, Mailand
Private collection, Milan

Seite page 4
Schlagzeug 2003
Blech (Polizeibus)
Sheet metal (Police van)
140 cm x 200 cm x 135 cm
Photo: Michael Sailstorfer
Privatsammlung, Mailand
Private collection, Milan

Seite page 9/10
Elektrosex 2005
Installationsansicht Installation view:
Light LAB, Museion Bozen
Straßenlaternen, Elektrobauteile, Strom
Street lamps, electronic components,
electricity
600 cm x 520 cm x 25 cm
Photos: Michael Sailstorfer
Ed. 3
Privatsammlung Asiago, Italien
Private collection Asiago, Italy

Seite page 14/15
Waldputz 2000
In Kooperation mit Alfred Kurz
In collaboration with Alfred Kurz
2,5 m x 4,8 m x 4,8 m
Photo: Michael Sailstorfer

Seite page 20/21
Bethlehem 2004
Motorrad Simson Duo, Stromgenerator,
Eisen, Stretchfolie, Neonlampen
Simson Duo Motorbike, electricity genera-
tor, iron, stretch film, neon lamps
Photo: Rolf Sturm
Privatsammlung, Torhout, Belgien
Private collection, Torhout, Belgium

Seite page 25/26
D-IBRB 2002
Sportflugzeug, Holz, Strom
Sports aeroplane, wood, electricity
170 cm x 250 cm x 120 cm
Photo (Baum Tree): Michael Sailstorfer
Photo (Dach Roof): Bert de Leenheer
Privatsammlung, Mechelen, Belgien
Private collection, Mechelen, Belgium

Seite page 32
Wohnen mit Verkehrsanbindung,
Großkatzbach 2001
Buswartehäuschen, Bett, Küche, Tisch,
Stuhl, Regal, Toilette, Tür, Beleuchtung,
Strom, Wasser
Bus shelter, bed, kitchen, table, chair,
bookcase, toilet, door, light, electricity,
water
Photos: Michael Sailstorfer

Seite page 33
Wohnen mit Verkehrsanbindung, Unter- /
Oberkorb 2001
Buswartehäuschen, Bett, Küche, Tisch,
Stuhl, Regal, Toilette, Tür, Beleuchtung,
Strom, Wasser
Bus shelter, bed, kitchen, table, chair,
bookcase, toilet, door, light, electricity,
water
Photos: Michael Sailstorfer

Seite page 36
Wohnen mit Verkehrsanbindung, Urtlfing
2001
Buswartehäuschen, Bett, Küche, Tisch,
Stuhl, Regal, Toilette, Tür, Beleuchtung,
Strom, Wasser
Bus shelter, bed, kitchen, table, chair,
bookcase, toilet, door, light, electricity,
water
Photos: Michael Sailstorfer

Seite page 37
Wohnen mit Verkehrsanbindung, Anzing /
Wilnham 2001
Buswartehäuschen, Bett, Küche, Tisch,
Stuhl, Regal, Toilette, Tür, Beleuchtung,
Strom, Wasser
Bus shelter, bed, kitchen, table, chair,
bookcase, toilet, door, light, electricity,
water
Photos: Michael Sailstorfer

Seite page 40
Herterichstraße 119 2001
Abbruchmaterial, Fotografie, Rahmen
Demolition material, photograph, frame
175 cm x 200 cm x 95 cm
Photo: Wilfried Petzi
Privatsammlung, München
Private collection, Munich

Seite page 44–48
3 Ster mit Ausblick 2002
In Kooperation mit Jürgen Heinert
In collaboration with Jürgen Heinert
Photos: Siegfried Wameser

Seite page 56, 58, 62/63
Heimatlied 2001
4 Wohnmobile, Holz, Strom, Wasser
4 camper vans, wood, electricity, water
375 cm x 410 cm x 360 cm
Photos: Siegfried Wameser
Sammlung My Private, Mailand
Collection My Private, Milan

Seite page 67
Modell – Und sie bewegt sich doch! 2002
Holz, Alufolie, Modellauto,
Modellstraßenlaterne, Farbe
Wood, aluminum foil, model car, model
streeet lamp, color
7,4 cm x 26,9 cm x 28,6 cm
Photo: Michael Sailstorfer
Sammlung My Private, Mailand
Collection My Private, Milan

Seite page 69–71
Und sie bewegt sich doch! 2002
Installationsansicht Installation view:
Museumsplatz, Städtisch Galerie im
Lenbachhaus, München
400 cm x 1500 cm x 500 cm
Mercedes Benz, Straßenlaterne,
Autoblech, Eisen, Strom
Mercedes Benz, street lamp, sheet metal,
iron, electricity
Photos: Siegfried Wameser

Seite page 76/77
Hoher Besuch 2005
Installationsansicht Installation view:
MARTa Herford
Helikopter, Elektromotor, Strom
Helicopter, electric motor, electricity
630 cm x 1340 cm x 1300 cm
Photo: Michael Sailstorfer
Sammlung MARTa Herford
MARTa Herford collection

Seite page 78
Modell – Reaktor 2005
Beton, Mikrophon, Aktivlautsprecher
Concrete, microphone, loudspeaker
Betonwürfel Concrete cube:
21 cm x 22,5 cm x 22,5 cm
Größe variabel
Size variable
Photo: Michael Sailstorfer
Ed. 5 + 1

Seite page 80–83
Reaktor 2005
Installationsansicht Installation view:
Diplomausstellung Degree show,
Akademie der Bildenden Künste München
Beton, Mikrophone, Mischpult, Verstärker,
Lautsprecher, Strom
Concrete, microphones, mixer, amplifier,
loudspeaker, electricity
Betonwürfel Concrete cube: 210 cm x
225 cm x 225 cm
Größe variabel Size variable
Photos: Rolf Sturm

Seite page 85
**Modell – Cast of the surface of the dark
side of the moon** 2005
Alufolie, Karton, Farbe
Aluminum foil, cardboard, color
12,1 cm x 24,2 cm x 24,2 cm
Photo: Michael Sailstorfer

Seite page 86/87
**Cast of the surface of the dark side of the
moon** 2005
Installationsansicht Installation view:
Rückkehr ins All, Galerie der Gegenwart,
Hamburger Kunsthalle
Fiberglas, Theaterstrahler
Fiberglass, spotlights
100 cm x 500 cm x 500 cm
Photo: Ulrich Jansen
Ed. 3

Seite page 90/91
Sternschnuppe 2002
Mercedes Benz, Straßenlaterne,
Gummiseile, Eisen, Seilwinde, Strom
Mercedes Benz, street lamp, rubber
ropes, iron, winch, electricity
510 cm x 500 cm x 200 cm
Photos: Siegfried Wameser
Sammlung My Private, Mailand
Collection My Private, Milan

Seite page 96
Modell – Dean & Marylou 2003
Gips, Plastik
Gypsum, plastic
8,6 cm x 9,8 cm x 19,2 cm
Photo: Michael Sailstorfer
Sammlung My Private, Mailand
Collection My Private, Milan

Seite page 98/99
Dean & Marylou 2003
Installationsansicht Installation view:
lothringer 13/halle, München
Blech (Stadtbus), Holz, Gummi, Balg
Sheet metal (city bus), wood, rubber,
bellows
280 cm x 260 cm x 800 cm
Photo: Jörg Koopmann
Privatsammlung, München
Private collection, Munich

Seite page 100
Versuchsaufbau Marilyn 2004
Installationsansicht Installation view:
Manifesta 5, San Sebastian, Spanien
Ventilator, Eisen, Gipskarton, Räder,
Mikrophon, Verstärker, Lautsprecher,
Strom
Fan, iron, plasterboard, wheels, micro-
phone, amplifier, loudspeaker, electricity
460 cm x 1100 cm x 170 cm
Photo: Michael Sailstorfer

Seite page 103, 106–109
Zeit ist keine Autobahn – Yokohama 2005
Installationsansicht Installation view:
Yokohama 2005: International Triennale
of Contemporary Art
Reifen, Eisen, Elektromotor, Strom
Tyres, iron, electric motor, electricity
Größe variabel
Size variable
Photos: Michael Sailstorfer

**Alle Arbeiten mit freundlicher
Genehmigung von
Courtesy of all works**
Johann König, Berlin
Jack Hanley Gallery, San Francisco /
Los Angeles
Zero..., Mailand
Galerie Zink & Gegner, München
Michael Sailstorfer

Michael Sailstorfer

geboren 1979 in Velden/Vils

1999–2005 Studium an der Akademie der Bildenden Künste München

2003–2004 MA Fine Arts, Goldsmiths College, University of London

2005 Diplom und Meisterschüler bei Prof. Olaf Metzel

born 1979 in Velden/Vils

1999–2005 Studied at the Akademie der Bildenden Künste München

2003–2004 MA Fine Arts, Goldsmiths College, University of London

2005 Diplom and Meisterschüler with Prof. Olaf Metzel

Einzelausstellungen Solo Exhibitions

2005 *Zeit ist keine Autobahn*, Rote Zelle, München

 U, Galerie Zink & Gegner, München

 Ursula-Blickle-Stiftung, Kraichtal

 Hoher Besuch, MARTa Herford

 Der Schein trügt, Jack Hanley Gallery, Los Angeles

 My Private #3, Cernusco Sul Naviglio, Mailand

 Zeit ist keine Autobahn, Zero..., Mailand

2004 *Dämmerung*, attitudes - espace d'arts contemporaines, Genf

2003 *Welttour*, Galerie Markus Richter, Berlin

 D-IBRB, Transit, Mechelen, Belgien

2002 *Und sie bewegt sich doch!*, Museumsplatz, Städtische Galerie im
 Lenbachhaus, München

 Heimatlied, Basement, Galerie Markus Richter, Berlin

Gruppenausstellungen Group Exhibitions

2005 *Lichtkunst aus Kunstlicht*, Zentrum für Kunst- und Medientechnologie
(ZKM), Museum für Neue Kunst, Karlsruhe
Talk to the Land, Andrew Kreps Gallery, New York
Yokohama 2005: International Triennale of Contemporary Art, Yokohama
Rückkehr ins All, Galerie der Gegenwart in der Hamburger Kunsthalle
LIGHT LAB. Alltägliche Kurzschlüsse, Museion, Bozen
Things Fall Apart All Over Again, Artists Space, New York
Kunstpreis der Böttcherstraße in Bremen 2005, Kunsthalle Bremen
Bewegliche Teile, Formen des Kinetischen, Museum Tinguely, Basel
Favoriten, Kunstbau, Städtische Galerie im Lenbachhaus, München
Light Sculpture - Scultura Leggera, 503 mulino, Vincenza, Italien
We Disagree, Andrew Kreps Gallery, New York

2004 *Window Cleaning Days Are Over*, The Empire, London
Bewegliche Teile , Formen des Kinetischen, Kunsthaus Graz
Bloomberg New Contemporaries 2004, The Curve, Barbican Centre,
London
Bloomberg New Contemporaries 2004, The Coach Shed, Liverpool
Biennale, Liverpool
Manifesta 5, San Sebastian, Spanien
Galerie Zink & Gegner, München
Biennale of Sydney, Sydney
Xtreme Houses, Halle 14, Stiftung Federkiel, Leipzig
Xtreme Houses, lothringer 13/halle, München
CLIMATS, cyclothymie des paysages, Centre national d'art et du paysage,
Vassivière
BHF live set + Sailstorfer, Zero..., Mailand

2003 *Wings of Art,* Ludwig-Forum für internationale Kunst, Aachen

 Wir, hier!, lothringer 13/halle, München

 Head on, Homeroom - Projektraum für zeitgenössische Kunst, München

 Fuoriuso 2003 - Great Expectations, Pescara, Italien

2002 *At least begin to make an end*, w139, Amsterdam

 3x1, Galerie Nusser & Baumgart, München

 Mit dem Kopf durch die Wand!, Akademiegalerie, München

 Oltre il giardino, Stadtpark, Rimini, Italien

 extra dunkel, Alte Mälzerei, Regensburg

2001 *junger westen 2001*, Kunsthalle Recklinghausen

 acht x anders, centro de arte joven, Madrid

Bibliografie

Bibliography

Bücher und Kataloge Books and catalogues

Bewegliche Teile (Ausst. Kat. Kunsthaus Graz / Museum Tinguely, Graz / Basel 2005),
S. 196f

Boellert, Arvid (Hrsg.), *Rohkunstbau 12. Kinderszenen,* Child's Play, Berlin 2005,
S. 114–117, 139

Casavecchia, Barbara, Daneri, Anna, *My private 3*, Mailand 2005

Favoriten. Neue Kunst in München, (Ausst. Kat. Städtische Galerie im Lenbachhaus
und im Kunstbau, München 2005), S.103–108

LIGHT LAB. Alltägliche Kurzschlüsse (Ausst. Kat. Museion – Museum für moderne und
zeitgenössische Kunst Bozen, Bozen 2005), S. 56–59

Menegoi, Simone, in: *Light Scuplture – Scultura leggera* (Ausst. Kat. 503 mulino,
Vincenza 2005), S. 108–113

Schafhausen, Nicolaus, Müller, Vanessa Joan, „Bausätze des Lebens", in: *Kunstpreis der
Böttcherstraße in Bremen* (Ausst. Kat. Kunsthalle Bremen, Bremen 2005), S. 32f

Yokohama 2005 (Ausst. Kat. International Triennale of Contemporary Art, Yokohama
2005), S. 152f

Rückkehr ins All (Ausst. Kat. Hamburger Kunsthalle/Siemens Arts Program, Hamburg
2005/2006), S. 118–123

Bloomberg New Contemporaries (Ausst. Kat. New Contemporaries (1988) Ltd, London
2004/2005), o. S.

Dämmerung (Ausst. Kat. attitudes, Genf, le journal n° 17, mai-juillet 2004), S. 3–11

Gisbourne, Mark, „Michael Sailstorfer (e-mail conversation, may 18, 2004)", in: *All
Due Intent* (Ausst. Kat. Manifesta 5. European Bienniale of Contemporary Art,
San Sebastian, 2004), S. 189–191

Kaßner, Franka, Matzner, Florian, Tezmen-Siegel, Jutta (Hrsg.), *Restrisiko.
AkademieGalerie 1999–2004*, München 2004, S. 12/02

On Reason and Emotion: Biennale of Sydney 2004 (Ausst. Kat. 14th Biennale of
Syndey, Syndey 2004), S. 194–197

W139 from Warmoesstraat to Post CS (Ausst. Kat W139, Amsterdam 2004), S. 14f

Hartle, Johan Frederik, „Von Bussen und Menschen", in: Schoen, Christian und Rosen, Margit (Hrsg.), *Wir, hier!* (Ausst. Kat. lothringer 13, München 2003), S. 52–59

Michael Sailstorfer - Welttour (Ausst. Kat. Galerie Markus Richter, Berlin 2003)

Wings of Art - Motiv Flugzeug (Ausst. Kat. Kunsthalle Darmstadt/Ludwig Forum für Internationale Kunst Aachen, Darmstadt/Aachen 2003/2004), S. 70–73

Kunstverein Ingolstadt e.V. (Hrsg.), *bewegt* (Ausst. Kat. Kunstverein Ingolstadt 2002/03, Ingolstadt 2002), o.S.

acht x anders (Ausst. Kat. Centro de arte joven, Madrid 2001), o.S.

Ullrich, Ferdinand (Hrsg.), *Kunstpreis Junger Westen 2001* (Ausst. Kat. Kunsthalle Recklinghausen 2001/02), Bielefeld 2001, S. 48f

Presse Articles

Anselm, Maria, „,Hoher Besuch' gelandet", in: *Herforder Zeitung*, 18. August 2005, o.S.

Bombelli, Ilaria, „Do It Yourselve", in: *Flash Art*, Juni/Juli 2005, S. 94–97

Braun, Hartmut, „Der Hubschrauber ist gelandet", in: *Neue Westfälische Zeitung*, 18. August 2005, o.S.

Bruce Haines, „Michael Sailstorfer. Between the earth and the sky", in: *Frieze*, Nr. 94, Okt. 2005, S. 193

Heise, Rüdiger, „Skulpturale Bubenstreiche", in: *Applaus Kultur-Magazin*, Nr. 11, Nov. 2005, S. 52–53

Liebs, Holger, „Ufo in Urtlfing. Der niederbayerische Bildhauer Michael Sailstorfer feiert internationale Erfolge", in: *Süddeutsche Zeitung*, Nr. 209, 10./11. Sept. 2005, S. 19

Liebs, Holger, „Das Ende der Genügsamkeit - Der Nomade: Michael Sailstorfer", in: *Art*, September 2005, S. 32f

Müller, Vanessa Joan, „Vanessa Joan Müller über Michael Sailstorfer", in: *Artist*,
Nr. 65, Nov. 2005, S. 4–7

Bonvinci, Gyonata, „Michael Sailstorfer", in: *Around Photography*, Nr. 3, Oktober-
Dezember 2004, S. 35–37

De Righi, Roberta, „Nonsens-Möbel und reizende Trümmer", in: *Münchner
Abendzeitung,* 22.04.2004, S. 20

„Michael Sailstorfer", in: „London's top 25 new artists". Beilage zur *Art Review*,
Juli/August 2004, S. 44f

Schlegel, Franz-Xaver, „Michael Sailstorfer – Welt mit Humor in Szene setzen", in:
kunsttermine, Nr. 2, Mai–Jul. 2004, S. 26–32

Wittneven, Katrin, „Michael Sailstorfer, Goldsmiths College", in: *Monopol – Magazin für
Kunst und Leben*, Nr. 3, August/September 2004, S. 82

„Die Hoffnungsträger. Wer 2003 die Kulturszene bereichern wird", in: *Süddeutsche
Zeitung*, Münchner Kultur, 7.1.2003, S. 56

Humpeneder, Anke, „Denken statt lenken", in: *Landshuter Zeitung*, 3.1.2003,
Feuilleton

Kohl, Ines, „Von Ferne winkt Karl Valentin", in: *Landshuter Zeitung*, 1.3.2003

Leinonnen, Jani, Sakkinen, Riko, „Pahinta on seuraavana aamuna", in: *taide,* 2/2003,
S. 50f

Maier, Anne, „München: Michael Sailstorfer", in: *Kunst-Bulletin*, Jan./Feb. 2003,
S. 71f

Rathgeber, Pirkko, „Reviews. Michael Sailstorfer. Lenbachhaus", in: *Flash Art*, No. 229
international, March-April, 2003, S. 116

Vele, Ivan Maria, „Michael Sailstorfer. Boiler's Choice", in: *Boiler*, Nr. 3, Okt–Dez.
2003, Eurek, S. 8–15

Zehentbauer, Markus, „Aufsteiger, Hoffnungsträger, Sternschnuppe", in: *Erdinger SZ*,
5./6. Juli 2003, S. R9

Gediehn, Coco, „Der Heimatforscher", in: *Elle Decoration*, Nr. 5, Sept./Okt. 2002, S. 84–86

Gockel, Cornelia, „Weltkugel mit Dieselantrieb", in: *Süddeutsche Zeitung*, 18.12.2002, Münchner Kultur

Hüster, Wiebke, „Ein Heimatlied vom Wohnwagen", in: *Frankfurter Allgemeine Zeitung*, 9.3.2002

Maier, Anne, „Berlin 1", in: *Contemporary*, June-July-August 2002, S. 104–106

Sonna, Birgit, „Der Überflieger", in: *Süddeutsche Zeitung*, 8.10.2002

Autoren
Authors

Massimilano Gioni ist künstlerischer Direktor der Nicola-Trussardi-Stiftung in Mailand. Gemeinsam mit Maurizio Cattelan und Ali Subotnick kuratiert er die bevorstehende Berliner Biennale (2006 in Berlin). Er war Co-Kurator der Manifesta 5 (2004 in San Sebastian, Spanien) und Mitglied im Kuratorenteam von *Monument to Now* (2004 in Athen). Massimiliano Gioni hat zahlreiche Ausstellungen und öffentliche Kunstprojekte in Mailand organisiert, unter anderem mit Darren Almond, Urs Fischer, Elmgreen und Dragset. Zusammen mit Cattelan und Subotnick leitet er die Wrong Gallery und ist Herausgeber der Zeitschrift *Charley and the Wrong Times*.

Massimiliano Gioni is the artistic director of the Nicola Trussardi Foundation in Milan. Together with Maurizio Cattelan and Ali Subotnick, he is curating the forthcoming Berlin Biennale (Berlin, 2006). Co-curator of Manifesta 5 (San Sebastian, Spain, 2004) and member of the curatorial team of *Monument to Now* (Athens, 2004), Massimiliano Gioni has organized many exhibitions and public art projects in the city of Milan with, among others, Darren Almond, Urs Fischer, Elmgreen and Dragset. With Cattelan and Subotnick, Gioni runs the Wrong Gallery and edits the magazine *Charley and The Wrong Times*.

Johan Frederik Hartle, Dr. phil., derzeit tätig am Institut für Philosophie der Universität von Amsterdam und als Lehrbeauftragter für Philosophie an der Kunstakademie Münster, promovierte mit einer Arbeit über Ästhetik und Politik des Raumes. Diverse Veröffentlichungen zur Kunst und Philosophie der Gegenwart.

Johan Frederik Hartle, Dr. phil., is currently on the staff of the Institute of Philosophy at the University of Amsterdam and a lecturer in philosophy at the Academy of Art in Münster. He was awarded his doctorate for a thesis on the aesthetics and politics of space. He has published widely on contemporary art and philosophy.

Max Hollein, 1969 in Wien geboren. Seit 2001 Direktor der Schirn Kunsthalle Frankfurt und ab 2006 auch Direktor des Städelschen Kunstinstituts und des Liebieghauses – Museum Alter Plastik. Davor von 1995 bis Ende 2000 am Solomon R. Guggenheim Museum in New York tätig. Max Hollein war Kommissär und Kurator des amerikanischen Pavillons bei der VII. Architekturbiennale in Venedig im Jahr 2000, ist Kommissär des österreichischen Pavillons für die Biennale in Venedig 2005 und Kurator des Salzburger Avantgardefestivals *kontra.com* anlässlich des Mozart-Jahres 2006. Kurator von Ausstellungen wie *Shopping, Jonathan Meese, Julian Schnabel, 3', Carsten Nicolai, Wunschwelten – Neue Romantik in der Kunst der Gegenwart* sowie Herausgeber zahlreicher Ausstellungskataloge. Vielfältige Publikationen und Vorträge zum Museumswesen, zur zeitgenössischen Kunst und Kunst der Moderne.

Max Hollein, Born in Vienna, Austria, in 1969. Director of the Schirn Kunsthalle Frankfurt since 2001 and Director of the Städel Museum and the Liebieghaus sculpture collection as of 2006. Worked at the Solomon R. Guggenheim Museum in New York from 1995 to the end of 2000. Max Hollein was commissioner and curator of the US pavilion at the 7th Venice Architecture Biennial in 2000 and is commissioner of the Austrian pavilion at the Venice Art Biennial 2005 and curator of the Salzburg avant-garde festival *kontra.com* on the occasion of the Mozart Year 2006. Curator of such exhibitions as *Shopping, Jonathan Meese, Julian Schnabel, "3', Carsten Nicolai, Ideal Worlds – New Romanticism in Contemporary Art,* as well as editor of numerous exhibition catalogues. Manifold publications and lectures on the museum, on contemporary art, and on modern art.

Simone Subal, geboren in Wien, lebt als freie Kuratorin und Autorin in New York.

Simone Subal is an independent curator and writer, living in New York. She is originally from Vienna.

Vielen Dank an
Thanks to

Cecilia Alemani, Taro Amano, Nini Andersen, Olivier Antoine, Ursula Blickle, Anna Brandl, Fam. Brenninger, Emma und Lena Bröcker, Maurizio Cafaro, Isabel Carlos, Barbara Casavecchia, Anna Daneri, Roberto Daolio, Ann Demeester, Markus Dicklhuber, Jean-Paul Felley, Fam. Fischbeck, Anna Friedel, Helmut Friedel, Susanne Gaensheimer, Klaus von Gaffron, Massimiliano Gioni, Mark Gisbourne, Stefano Giuriati, Ingvild Goetz, Petra Gregorovic, Rolf Habermann, Jack Hanley Gallery (San Francisco / Los Angeles), Johan Frederik Hartle, Christoph Heinrich, Markus Heinzelmann, Julian Heynen, Jan Hoet, Max Hollein, Julia Höner, Institut für moderne Kunst Nürnberg, Olivier Kaeser, Franka Kaßner, Eriko Kimura, Lars Klemm, Johann König (Berlin), Hubert Kostner, Thomas Kratz, Marta Kuzma, Klaus Lintl, Doris Lösch, Anne Maier, Michael Mayer, Pierluigi Mazzari, Florian Merker, Olaf Metzel, Ivo Moser, Gregor Passens, Letizia Ragaglia, Timo Reger, Margit Rosen, Stephanie Rosenthal, Manfred Rothenberger, Anna Sailstorfer, Josef Sailstorfer, Nicolaus Schafhausen, Annette Scherer, Christian Schön, Katja Schroeder, Ludwig Seibert, Courtenay Smith, Maria O. Stahl, Mike Stiegler, Rolf Sturm, Simone Subal, Saša Thomann, Michael Vogel, Florian Waldvogel, Peter Welz, Felix Wenzel, Martin Wöhrl, Zero... (Mailand), Galerie Zink & Gegner (München).

Impressum
About this publication

Herausgeber Editor
Nicolaus Schafhausen für die
Ursula Blickle Stiftung

Die Publikation erscheint anlässlich der
Ausstellung von Michael Sailstorfer in der
Ursula Blickle Stiftung,
11.09.2005–16.10.2005
Kurator der Ausstellung: Nicolaus Schafhausen

Gestaltung Graphic design
Timo Reger

Redaktion und Lektorat Editing and Proof-
Reading
Esther Kiener, Anke Schlecht

Texte Texts
Massimiliano Gioni, Max Hollein, Johan Frederik
Hartle, Simone Subal

Übersetzung Translation
Jeremy Gaines

Schrift Typeface
Trade Gothic

Papier Paper
Luxosatin 170 g/qm

Lithographie Reprographics
DZA Satz und Bild GmbH, Altenburg

Herstellung Print and Binding
Grafisches Centrum Cuno GmbH & Co. KG,
Calbe

Auflage Edition
1300 Exemplare copies

ISBN 3-936711-86-0

Bibliografische Information
Der Deutschen Bibliothek
Die Deutsche Bibliothek verzeichnet diese
Publikation in der Deutschen Nationalbiblio-
grafie; detaillierte bibliografische Daten sind
im Internet über http://dnb.ddb.de abrufbar.

Bibliographic information published by
Die Deutsche Bibliothek
Die Deutsche Bibliothek lists this publication in
the Deutsche Nationalbibliografie; detailed
bibliographic data is available in the Internet at
http://dnb.ddb.de.

Distributed in the United Kingdom
Cornerhouse Publications
70 Oxford Street, Manchester M1 5 NH, UK
phone 0044-(0)161-200 15 03
fax 0044-(0)161-200 15 04

Distributed outside Europe
D.A.P./Distributed Art Publishers, Inc., New York
155 Sixth Avenue, 2nd Floor, New York, NY
10013, USA
phone 001-(0)212-627 19 99
fax 001-(0)212-627 94 84